IMAGES
of America

PLYMOUTH'S
FIRST CENTURY

INNOVATORS AND INDUSTRY

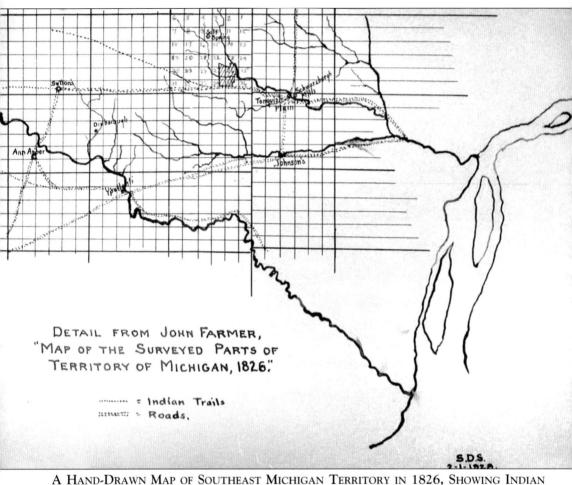

DETAIL FROM JOHN FARMER,
"MAP OF THE SURVEYED PARTS OF
TERRITORY OF MICHIGAN, 1826."

·········· = Indian Trails
⠶⠶⠶⠶ = Roads.

S.D.S.
2-1-1928.

A HAND-DRAWN MAP OF SOUTHEAST MICHIGAN TERRITORY IN 1826, SHOWING INDIAN TRAILS AND ROADS. The township in the top center that contains section numbers is Plymouth Township and the outlined area within the township later became the Village of Plymouth. At this time Plymouth was known only by surveyor's designations—T1S-R8E or Township One South, Range Eight East.

IMAGES
of America

PLYMOUTH'S
FIRST CENTURY

INNOVATORS AND INDUSTRY

Elizabeth Kelley Kerstens

ARCADIA

First Printed 2002.
Reprinted 2003.

Published by Arcadia Publishing,
an imprint of Tempus Publishing, Inc.
3047 N. Lincoln Ave., Suite 410
Chicago, IL 60657

Printed in Great Britain.

Library of Congress Catalog Card Number: 2002105007

For all general information contact Arcadia Publishing at:
Telephone 843-853-2070
Fax 843-853-0044
E-Mail sales@arcadiapublishing.com

For customer service and orders:
Toll-Free 1-888-313-2665

Visit us on the internet at http://www.arcadiapublishing.com

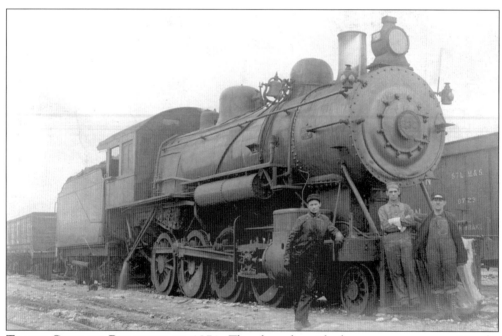

TRAINS CAME TO PLYMOUTH IN 1871. They brought with them greater opportunities for commerce and travel. Two sets of railroad tracks cross in Plymouth Township, allowing access in all compass directions. The railroads are still a very noticeable presence in the Plymouth community, even though there is no longer passenger service from here.

CONTENTS

ACKNOWLEDGMENTS

I am deeply grateful to everyone that helped pull this book together, but especially Beth Stewart, director of the Plymouth Historical Museum, Dan LeBlond, president of the Plymouth Historical Society, Garry Packard, a museum volunteer archivist, and Janice Karrer, a museum volunteer. All four of these people were instrumental in helping me find photos and answers to my many questions about the history of Plymouth. I'd also like to thank Howard "Howdy" Schryer, who used his 88 years of memories of Plymouth to help me sort out some details. There were others who gave assistance along the way and I give my thanks to all of you, too! Most of the photos and postcards used in this book are from the impressive collection of the Plymouth Historical Museum, a privately funded organization run by the Plymouth Historical Society. Members of the society over the years have been extremely generous in depositing their precious artifacts of the history and growth of Plymouth so future generations can understand why their community is so vibrant. The photos that are from private collections have been so noted in the text. Finally, I'd like to thank my husband, Marty Kerstens, who is always supportive of the projects I over commit to, spent many hours editing the text for this book, and even provided one of his own images of his hometown.

INTRODUCTION

Plymouth, Michigan, in the year 2002 covers nearly sixteen square miles that include the City of Plymouth and Plymouth Township. Since its founding in 1825, Plymouth has been a thriving community with many activities for residents and more than its share of innovators. The air rifle was invented in Plymouth in the late 1800s and put the community on the map worldwide. The air rifle invention spawned other weapons inventions in the community, including an inexpensive .22 caliber rifle. Plymouth was also closely connected to the growth of the automobile, with some of the related industries being headquartered in our community. In fact, the Alter Motor Car was invented here in 1914, although it had a short, 3-year life span.

Plymouth, like other small communities, contributed its share of people and effort to the Civil War. A militia company was raised that was largely made of Plymouth area men, and they suffered their share of casualties. Additionally, Plymouth was a stop on the Underground Railroad before and during the Civil War, as many people here did not believe in slavery. After the war, the Union veterans participated in making memorials and created a local chapter of the Grand Army of the Republic that lasted into the second decade of the twentieth century.

Saw and grist mills were the only industries in the community during the early years. At one time, there were seven grist mills and six saw mills in the Township of Plymouth, all doing a thriving business. By far, the majority of the population was engaged in farming well into the twentieth century and the mills provided much needed services for these farmers. The fact that the Middle Rouge River runs through the Plymouth community helped to foster the growth of the mills and the existence of the mills eventually worked well in the plans of Henry Ford in the growth of his village industries. Ford purchased several Plymouth mills and turned the buildings or property into small factories "on American streams within easy reach of farming districts."

Plymouth is also a crossroads for the railroad industry, and has been since 1871 when two railroads met and crossed in the village. The railroads gave Plymouth residents easier access to downtown Detroit (about twenty miles away) and to communities north, south, and west. Additionally, the railroads brought business to town. The railroads are still a very noticeable presence in the Plymouth community, even though there is no longer passenger service from here.

In choosing images for this book, I have tried to capture the essence of Plymouth during its first century. The early years were difficult to show photographically, so other types of images were relied upon to tell the story. In the later years covered by this book, there were so many images available it was difficult to choose what to put in and what to leave out. Important omissions in documenting the first century of Plymouth often occurred because the images simply weren't available. But our photographic heritage is rich and I hope that the images that were selected will stir the imagination, and interest all in the history of Plymouth, Michigan.

One
1825–1860

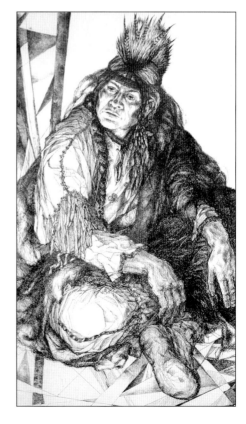

TONQUISH, CHIEF OF THE POTTOWATTOMIE INDIANS. He lived with his tribe in the area that is now Plymouth and Nankin Townships. Early settlers frequently had run-ins with the Pottowattomies, who would appear at the homes of the settlers and either demand or steal food. Tonquish was killed in 1819 by a band of settlers seeking to avenge the death of one of their children. Tonquish Creek, which runs through Plymouth, was buried under the city during the twentieth century.

ON A TRAIL WHERE INDIANS WALKED—A LITTLE HISTORY OF PLYMOUTH'S BEGINNINGS.
Illustrations and text by Denise Santeiu

On a trail where Indians walked, near a hill where Indians prayed, a pioneer arrived one day, he looked around and decided to stay.
The year was 1825. They needed a shelter to survive, so William Starkweather, his wife and son, rolled up their sleeves for the work to be done.
There were bears and deer with warm pelts to wear or trade, by trapping these forest animals, a fortune could be made!

There was food aplenty for man and beast, schools of fish in a nearby creek, a forest full of turkeys, rabbits, and other good things to eat.

Their people walked this trail for hundreds of years, soon they would walk a Trail of Tears. The Indians would cruelly be sent.

North and west by the "Government," far from the forest home, that they knew the best, to dry plains land far in the west.

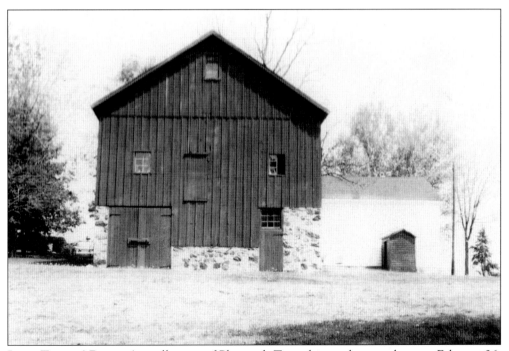

JOHN TIBBITS' BARN. A small group of Plymouth Township settlers met here on February 26, 1827, to select a name for the community. Choices included Pekin, LeRoy, and Plymouth, with the latter being the choice of Territorial Governor Lewis Cass. The barn is still standing.

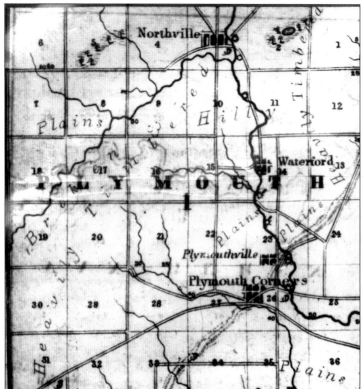

PLYMOUTH TOWNSHIP AS DEPICTED ON AN 1840 MAP. The original township included what is now Canton Township, which separated from Plymouth in 1834, and Northville Township, which broke away in 1898. The Village of Plymouth was incorporated in 1867, but was called Plymouth Corners prior to that. Northville was so named because it was at the "North end of the Village of Plymouth."

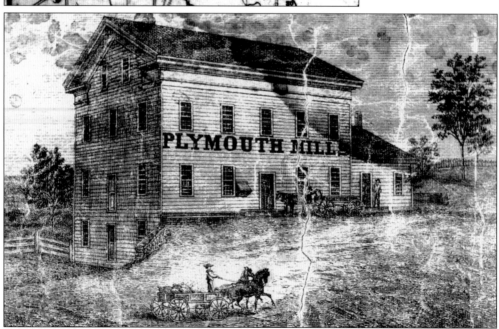

PLYMOUTH MILLS WAS BUILT IN 1845. On an 1860 Wayne County map illustration (above), S. Hardenbergh is listed as the proprietor. The mill, built by Henry Holbrook, became Wilcox Mills in 1879 and was in continuous operation until Henry Ford tore it down and built a small plant for the Ford Motor Company's Village Industry Project.

PHOENIX MILL. On the other side of Phoenix Bridge, this was on the site of the extinct village of Phoenix. A mill was located at this site from 1840–1905, when the gristmill burned down. It was also the site of the Matthews Distillery, which produced "Plymouth Wheat Flakes." Henry Ford bought and rebuilt the mill, as well as the adjacent dam after it broke in 1920. The new mill, opened in 1922, produced electrical parts, voltage regulators, and switches, and employed an "all-women" work force.

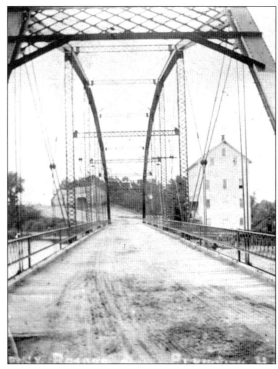

THE PLYMOUTH CARDING MILL. Built by John Gunsolly in the 1850s, it was located along what is now Hines Park Drive. The mill was used for the carding of wool. The mill was removed to Greenfield Village in Dearborn, Michigan. (Courtesy of Henry Ford Museum.)

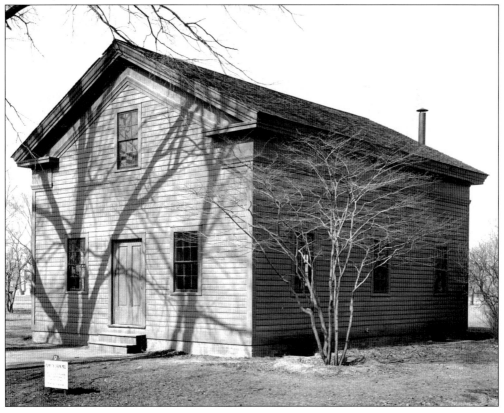

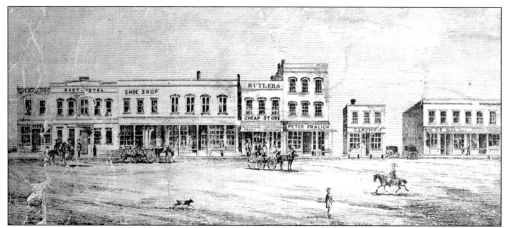

THE "PHOENIX BLOCK" OF MAIN STREET AS DEPICTED ON AN 1860 WAYNE COUNTY MAP.
This row of buildings was destroyed by fire on May 5, 1856. The fire started in Root's Hotel
(left) and swept north to engulf the entire block of buildings.

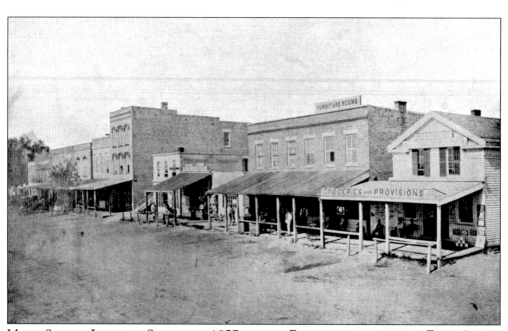

MAIN STREET LOOKING SOUTH IN 1857, AFTER REBUILDING FROM THE FIRE. A sign,
projecting from a building in the middle of the block, reads "Cash for Hides."

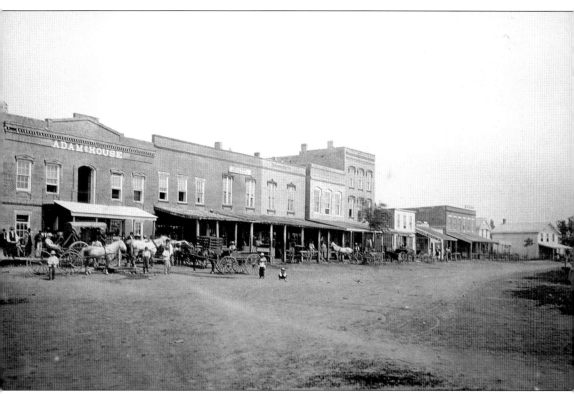

Looking North at Plymouth's Main Business Section in 1857. This was ten years before the village was incorporated. The first village election took place in the Adams House (far left). The stagecoach in front of the hotel is probably the one which ran daily to Ann Arbor. The building on the far right was Conner's Hardware, established in 1857 by Michael Conner. The Conners built a brick building in 1898, which still stands on the northwest corner of Main Street and Penniman Avenue.

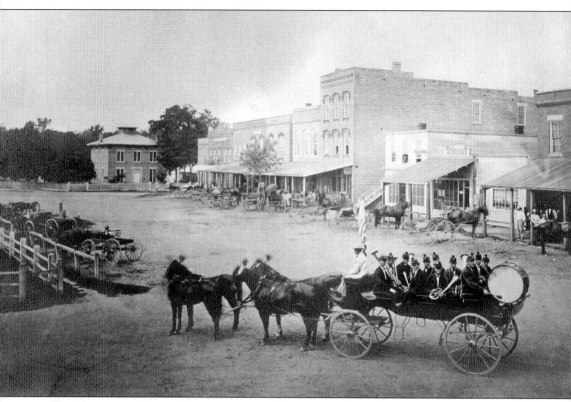

The Plymouth Band Preparing for a Fourth of July Celebration in about 1857.
Band members included Michael Conner, Andrew Reynders, Peter Gayde, Isaac Gleason, Ashley Perrin, Wilson Roe, Charles Roe, George Root, Erasmus Lombard, Dewitt Taylor, and John Steele. The house at the far end of the street was John Fuller's house, built on the site of the first home in Plymouth where George Starkweather was born (see next page).

GEORGE STARKWEATHER (FEBRUARY 20, 1826–FEBRUARY 6, 1907), THE FIRST WHITE CHILD BORN IN THE CURRENT TOWNSHIP OF PLYMOUTH. He was the son of pioneers William and Mary Keziah Starkweather. He married Amelia (on right in photo), daughter of Jehiel and Mary Davis of Plymouth, August 19, 1861. During his career, George was a member of the Michigan State Legislature (elected in 1854) and was president of the Village of Plymouth in 1898.

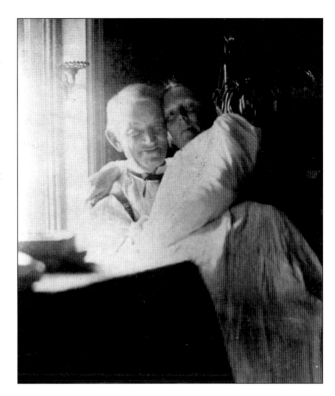

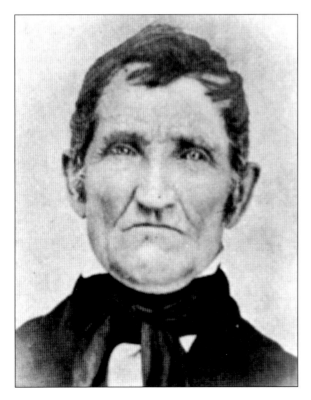

JOHN KELLOGG (1786–1871) FOUGHT IN THE WAR OF 1812. He settled in Plymouth Township in 1834. He bought a tract of land that comprises most of today's City of Plymouth. A year later, he brought his wife, five sons and two daughters to his new home on what is now Ann Arbor Trail. Shortly thereafter, he laid out the town of Plymouth, selling off business and residential lots and donating the parks, church and school sites, and streets. Kellogg built a hotel on the corner of Main Street and Ann Arbor Road (now Ann Arbor Trail) that became a stagecoach stop on the road between Ann Arbor and Detroit.

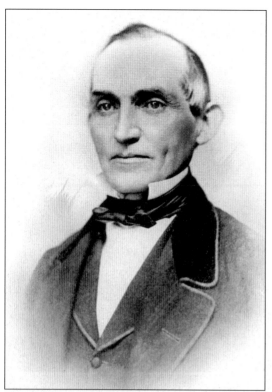

JOSHUA SCATTERGOOD (APRIL 7, 1814–AUGUST 18, 1886), PLYMOUTH'S POSTMASTER FROM 1843–49. Scattergood settled in Plymouth in 1836 and was engaged in a general mercantile business until he moved from the area in 1866. In 1840 he was elected as Plymouth Township Clerk and in 1845 he was elected Justice of the Peace.

ANSON H. POLLEY (B. 1828) AND HIS WIFE MARGARET (B. 1828) (BELOW). They were two of Plymouth's Earliest Settlers. He was a blacksmith; his shop was next to where the Plymouth City Hall now stands. His house later became the home of the Plymouth Historical Society Museum, before it was torn down to build a larger facility.

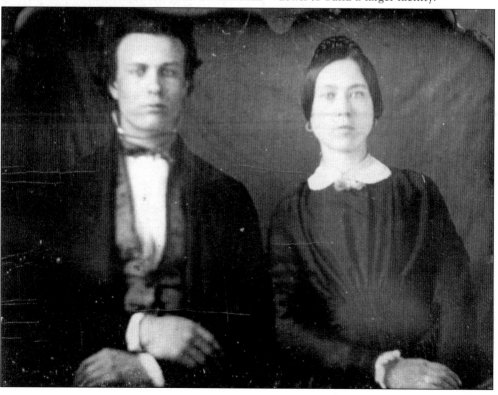

EBENEZER JENCKES PENNIMAN (1804–1890). Plymouth's First Member of the U.S. Congress, he served as a Congressman from 1851-53. His home at 1160 Sutton Street (now Penniman Avenue) (below) was built in the 1840s. Daughter Kate Penniman Allen lived in the home with her husband, William O. Allen, after her father's death. The building is now the rectory for Our Lady of Good Counsel Catholic Church.

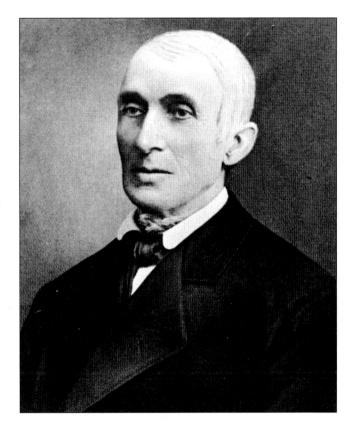

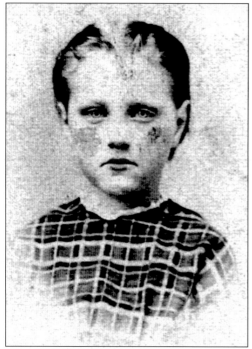
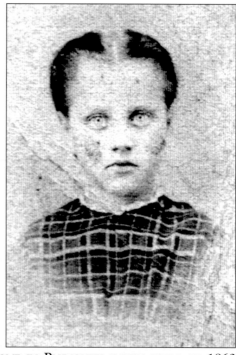

ENGRAVING OF THE FRANCIS W. FAIRMAN HOME IN PLYMOUTH TAKEN FROM AN 1860 WAYNE COUNTY MAP. Francis (July 11, 1822–July 26, 1894) and Cornelia E. Westfall, his wife, were the parents of five children, including twins Kathryn "Kittie" (left) and Lillian "Lillie" Isabel (right). The twins were born October 28, 1859; Kittie died May 30, 1876 at the age of 16, and is buried in Kinyon Cemetery, on the corner of Ridge and Gyde Roads, along with other family members. Lillie died May 28, 1951 and is buried next to her twin sister.

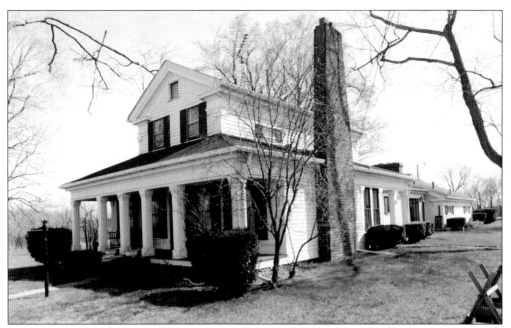

THE OLD WILCOX HOUSE, BUILT BY S. HARDENBURGH IN THE GREEK REVIVAL STYLE ABOUT 1840. The house is still standing at 1142 Holbrook and was once part of a 320-acre wood and grist mill farm purchased by John and George Wilcox, with their father David, in 1870.

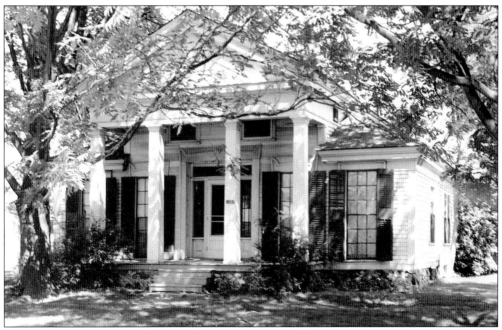

THE BIRCH-SOBER HOUSE. The Greek Revival style house was built by a Plymouth farmer in about 1845. The home, known as the Birch House because of the Robert Birch family that lived there from the late 1800s to 1932, was originally on S. Main Street but was moved in 1971 to 48760 N. Territorial Road by Mrs. Marion Sober.

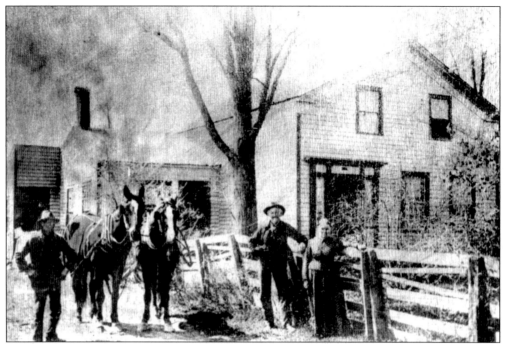

Samuel Widmaier (in center of picture), his Wife and Son on their Farm at 46303 Five Mile Road (formerly Phoenix Road), Plymouth Township, in about 1890. The farmhouse was built before 1860 and was torn down in the 1990s for industrial development. (Photo courtesy of William and Marjorie Taylor.)

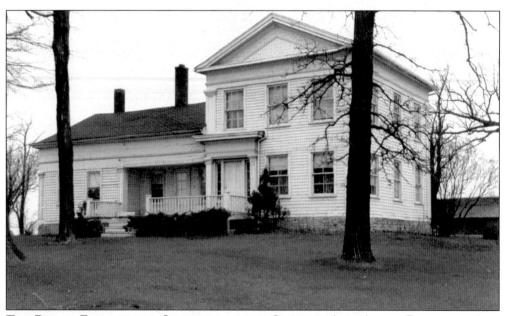

The Brinks Farm at the Junction of the Current Ann Arbor Road and Ann Arbor Trail West of Plymouth. The home was built in the 1850s and was a stop on the Underground Railroad. It was torn down in the 1970s.

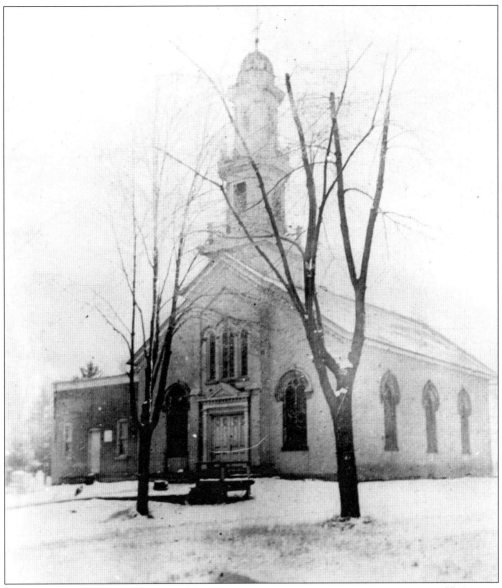

THE PRESBYTERIAN CONGREGATION BEGAN MEETING IN PLYMOUTH'S PRIVATE HOMES IN 1835. The first church building was brick and was used until the church above was built in 1849. The previous church building was sold to the Baptists. The Presbyterian Church is located at the curve on Church Street just before it intersects Main Street. The church grounds were originally used as the village cemetery. Over the years, the church has suffered fire damage and has been renovated several times.

THE FIRST BAPTIST CHURCH ON NORTH MILL STREET. Built in 1856, the building was later remodeled and then sold in 1968. The congregation then moved to a newer structure on North Territorial Road near Ridgewood.

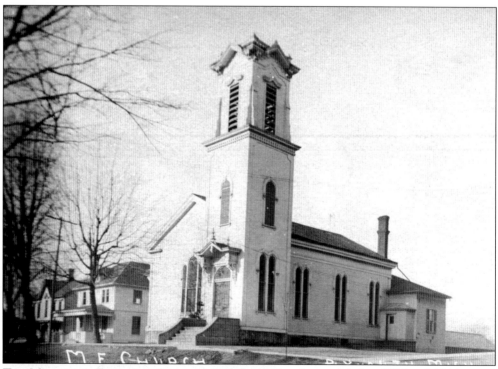

THE METHODIST EPISCOPAL CHURCH. Built in 1848 and remodeled in 1874 and 1914, it was located on Church Street, next to the Plymouth High School. The church burned, along with the high school, in March 1916.

Two
1861–1870

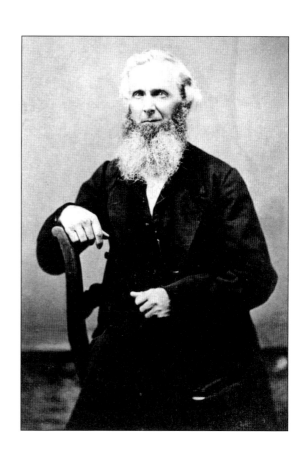

BETHUEL NOYES, FIRST VILLAGE OF
PLYMOUTH PRESIDENT, 1867–68.

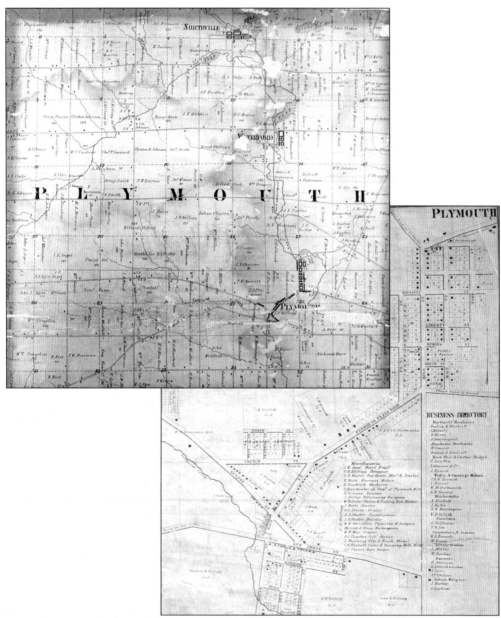

1860 MAP OF PLYMOUTH TOWNSHIP. This map, and the insert of Plymouth, were published by Geil, Harley, and Siverd of Philadelphia. Note the extinct town of Waterford on the road between Plymouth and Northville. The business directory for the village of Plymouth lists proprietors who made a lasting mark on the area, including hardware merchants M. Conner and Fralick and Woodruff, carpenters and joiners W. A. Bassett (later an undertaker as well) and M. Young, farmer G. A. Starkweather, druggist C. R. Kellogg, jeweler J. Steele, foundryman A. A. Shafer, and cider and fanning mill proprietor C. H. Bennett.

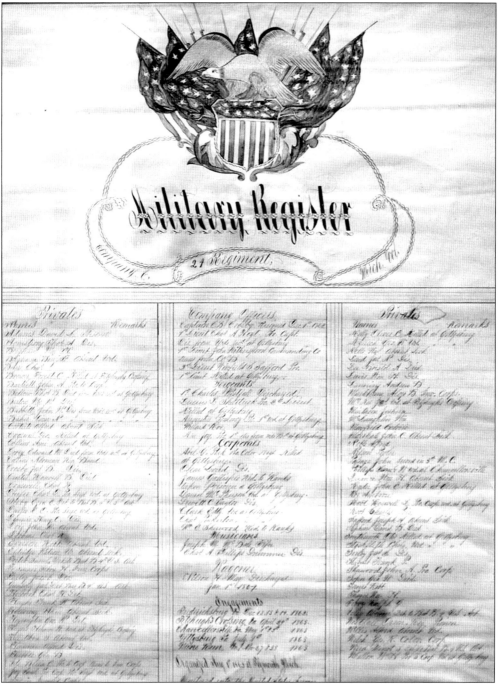

THE 24TH MICHIGAN INFANTRY REGIMENT, COMPANY C, COMPOSED LARGELY OF MEN FROM THE PLYMOUTH AREA. The company was organized in Plymouth on August 1, 1862 and was mustered into United States service at Detroit on August 15, 1862. The company participated in the following campaigns: Fredericksburg, Fitzhugh's Crossing, Chancellorsville, Gettysburg, and Mine Run. Second Lieutenant Lucius Shattuck of Plymouth was killed on the first day of the three-day Gettysburg Battle. His letters are in the Plymouth Historical Museum's Archives.

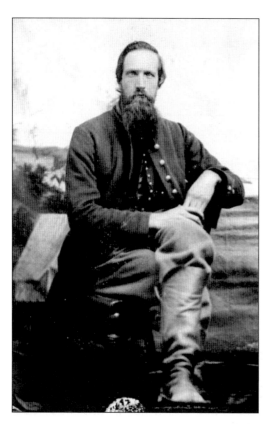

RALPH G. TERRY (AUGUST 16, 1831–AUGUST 23, 1898), PRIVATE, CO. C, 24TH MICHIGAN INFANTRY REGIMENT (LEFT). (photo courtesy of descendant Hal Young.) James Gunsolly (bottom photo, second from right), private, Co. C, 24th Michigan Infantry Regiment on detached service to Stewarts Battery B, 4th U.S. Artillery.

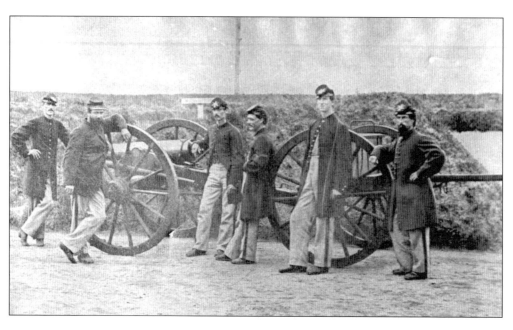

(TOP PHOTO) SERGEANT WILLARD ROE, A PLYMOUTH NATIVE, SERVING WITH THE SIGNAL CORPS AT WASHINGTON, D.C. (MIDDLE ROW, ON LEFT). (Below) Arthur Stevens (February 16, 1841–1936) was a veteran of the 5th Michigan Infantry Regiment. He was the son of Ammon and Martha Gates Stevens. Before his death in 1936, he was the last surviving Civil War veteran and last member of the Grand Army of the Republic in Plymouth.

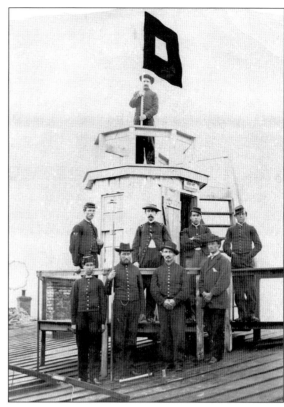

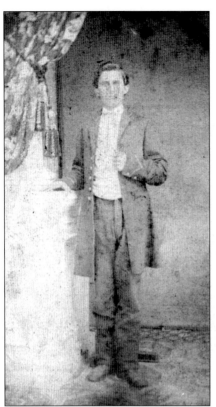

ROSWELL LINCOLN ROOT (JULY 25, 1841–JUNE 1903), SON OF STEVEN ROOT AND GRANDSON OF PLYMOUTH PIONEER ROSWELL ROOT. Root owned a drug store in Plymouth, was general manager of the Plymouth Iron Windmill Company, and served as a private in Co. C, 24th Michigan Infantry Regiment. Roswell never married.

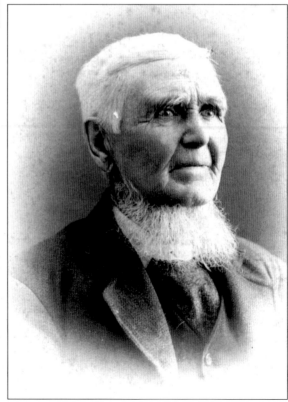

ISAAC N. HEDDON (1808–1892) SERVED AS A HIGHWAY COMMISSIONER AND WAS ELECTED TRUSTEE IN THE FIRST VILLAGE OF PLYMOUTH ELECTION IN 1867.

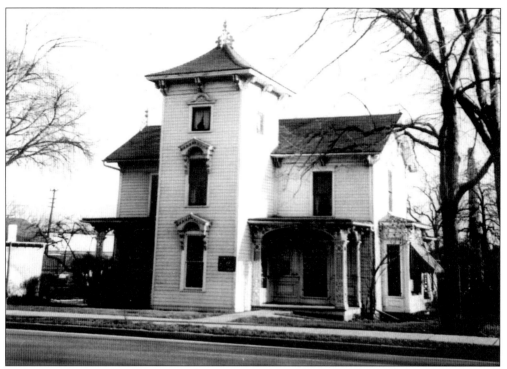

THE ROE HOME ON MAIN AND UNION STREETS BEFORE IT WAS TORN DOWN IN 1960. The house was built in 1868 by Charles Roe, a carpenter and cabinetmaker.

THE JOHN STEELE HOME ON THE CORNER OF SOUTH MAIN AND MAPLE STREETS. Mr. & Mrs. Steele, daughter Nellie, and son Louis lived here from about 1870. John had a jewelry and clock repair store in Plymouth.

THE CASSIUS KELLOGG HOUSE, STILL STANDING, AT 1107 W. ANN ARBOR TRAIL (FORMERLY ANN ARBOR ROAD), BUILT IN 1861. In 1858, John Kellogg sold his son Cassius 50 acres of land for $2,000 on which he built this Gothic Revival home, opposite his father's house. John Kellogg was an early settler in Plymouth and owned most of the land on which the current City of Plymouth now sits.

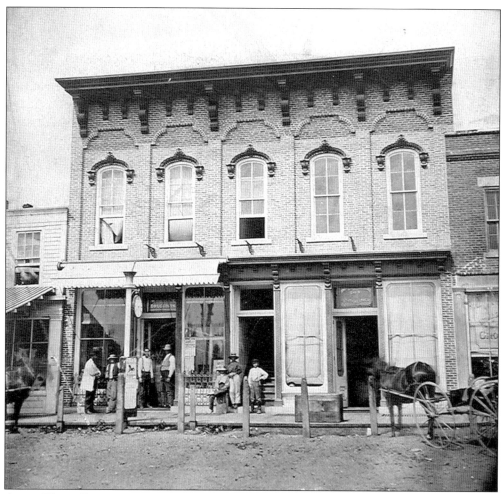

AMITY HALL, BUILT IN 1869 AND DESTROYED BY FIRE IN 1893. The hall was on the second story of the above building and was the principal place for public meetings, dances, and home-talent plays. Below the hall were two stores: John Steele's jewelry store combined with Roswell Root's drug store at left and George Starkweather's general merchandise store on the right. Roswell Root, John Steele, and C. A. Frisbee are standing in front of Steele's store.

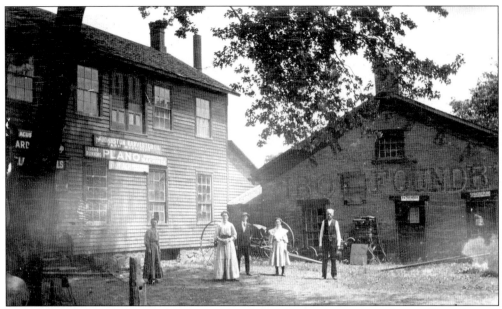

THE A. A. SHAFER IRON FOUNDRY ON ANN ARBOR ROAD (NOW ANN ARBOR TRAIL) NEAR THE APEX OF KELLOGG PARK. Shafer's Foundry was listed in the 1860 business directory and manufactured plow points and other iron work articles for western Wayne and eastern Washtenaw counties. The building on the left sold farm machinery.

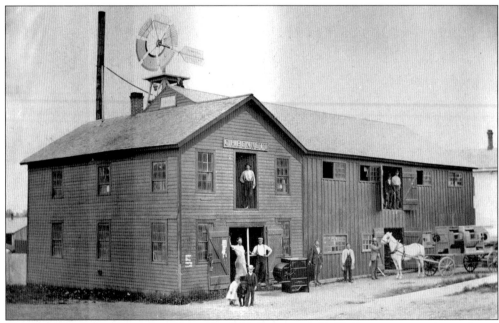

THE FANNING MILL FACTORY. Owned by C.H. Bennett and L.H. Bennett, it was located at at the southwest corner of Main and Union Streets. According to Charlie Bennett, the son of L.H. Bennett, this was the first factory built in Plymouth. He is the boy at the right of the dog in the foreground. This photo was taken in about 1870.

Three
1871–1880

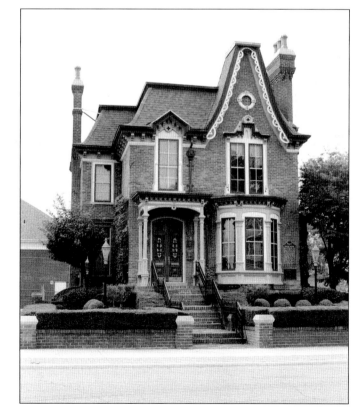

A High Victorian
Gothic Style House
Built in 1875 in the
Fashionable Section of
Town by Henry Baker.
The home was built for
durability; the outside walls
have two layers of brick
with an air space between
them. The home, at 233 S.
Main Street, remained in
the hands of the original
owners until 1943, and is
now used as a commercial
building. Henry Baker was
the chairman of the board
and president of Daisy
Manufacturing Company.
(Photo by Marty Kerstens.)

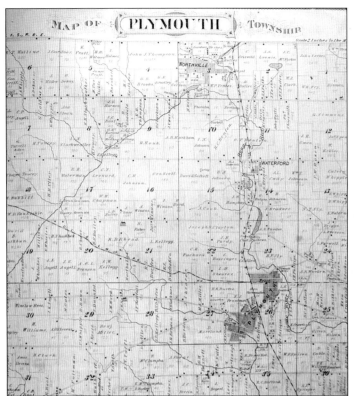

PLYMOUTH TOWNSHIP
AND THE VILLAGE OF
PLYMOUTH, TAKEN
FROM AN 1876 WAYNE
COUNTY ATLAS.
Landowners are clearly
marked on the township
map. Growth in the
village is apparent in the
additions in the northern
end of the village where
the railroad tracks came
through.

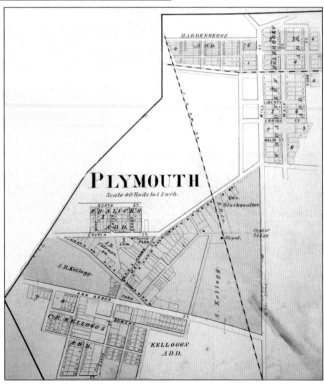

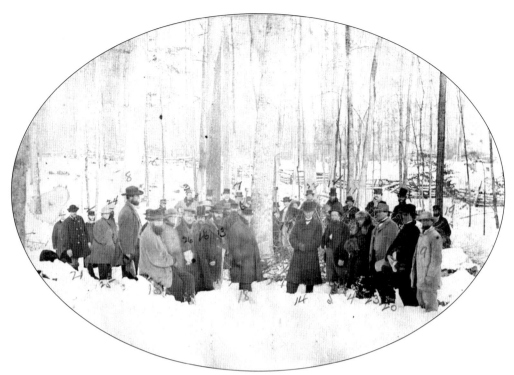

TREE FELLING CEREMONY AT THE SITE WHERE THE HOLLY-WAYNE RAILROAD DEPOT WAS BUILT IN 1870–71. In 1871, two railroads crisscrossed in Plymouth. The Detroit, Lansing, and Lake Michigan line ran east and west and gave residents access to Detroit and Lansing. The Holly, Wayne, and Monroe line ran between Holly and Monroe. The depot that was built on this site was moved in 1918 to be used for hay storage at McLaren's Coal and Lumber Yard. It burned down a few years later. Daisy Manufacturing Company was later built on the original site of the depot.

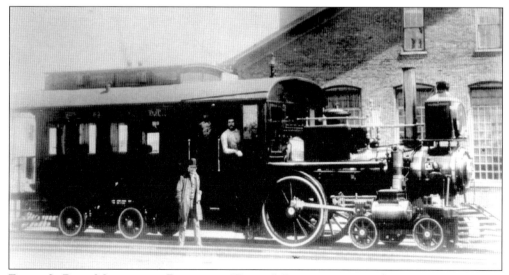

FLINT & PERE MARQUETTE RAILROAD "PEGGY" BUILT IN 1873. Flint & Pere Marquette Railroad took over the Holly, Wayne, and Monroe line before 1890.

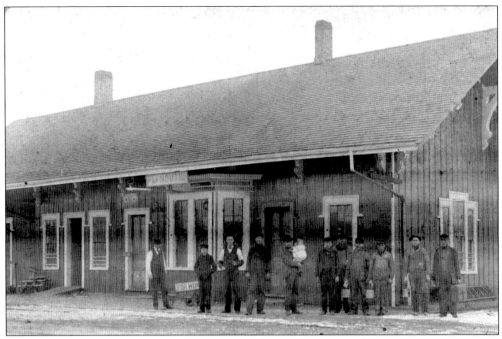

THE PERE MARQUETTE RAILROAD STATION IN PLYMOUTH, LOCATED ON STARKWEATHER ROAD IN OLD VILLAGE NEXT TO THE EAST-WEST TRACKS. This building, built in 1871, is still standing and is used as a commercial property.

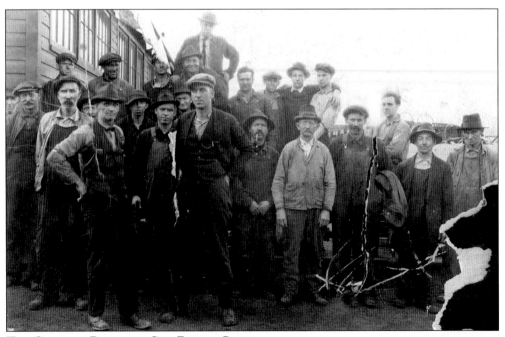

THE ORIGINAL RAILROAD CAR REPAIR CREW.

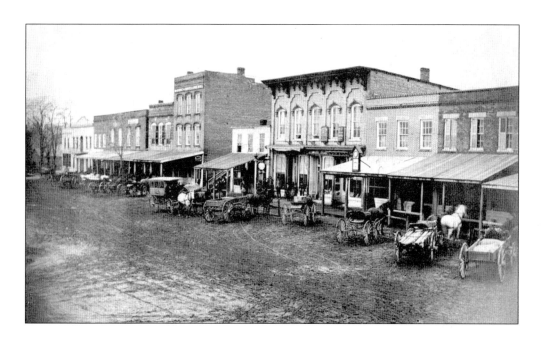

(ABOVE) PLYMOUTH'S MAIN STREET ABOUT 1880. (BELOW) ANOTHER CLUSTER OF
BUILDINGS ON S. MAIN STREET NORTH OF SUTTON STREET (NOW PENNIMAN AVENUE). In
the 1880s, the left half was Toot Cable's store and the right half was Anderson's Hardware. The
second floor was occupied by Lodge Hall (left) and the Grand Army of the Republic (GAR)
Hall (right).

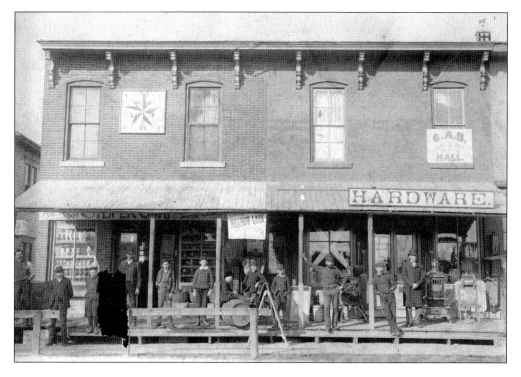

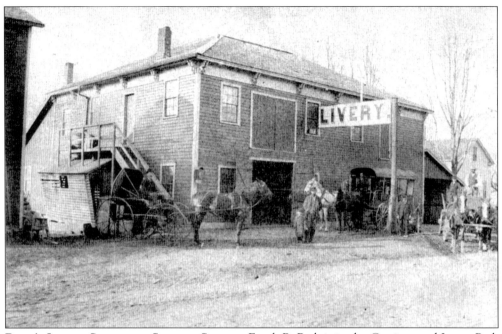

PARK'S LIVERY STABLE ON SUTTON STREET. Frank B. Park is in the Carriage and James Park is by the Post. Harry Robinson ran this business beginning in 1886. (Photo courtesy of Garry Packard.)

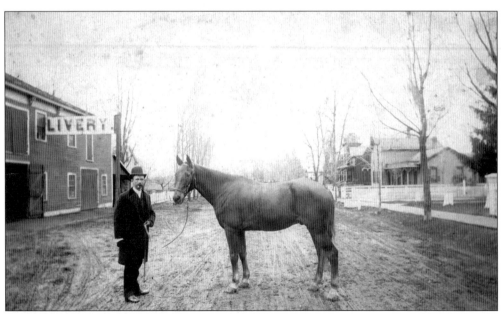

JACK HOLLOWAY AND HIS HORSE IN FRONT OF PARK'S LIVERY IN ABOUT 1876.

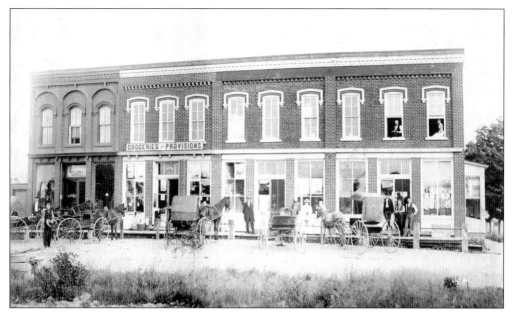

LIBERTY STREET STORES IN BUILDINGS BUILT IN 1871. They included, (from left) John Mieler's drugs, Peter Gayde's grocery, and George Starkweather's General Merchandise. Starkweather relocated here from Main Street when the railroads came through because he thought this would be the center of business activity. That never happened.

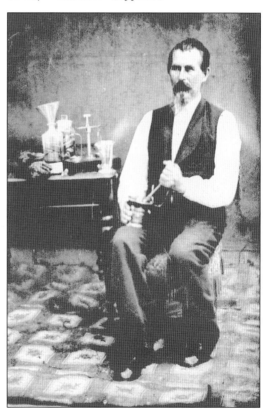

JOHN MIELER, PHARMACIST, AND OWNER OF THE DRUG STORE ON THE LEFT END OF THE BUILDING IN TOP PHOTO.

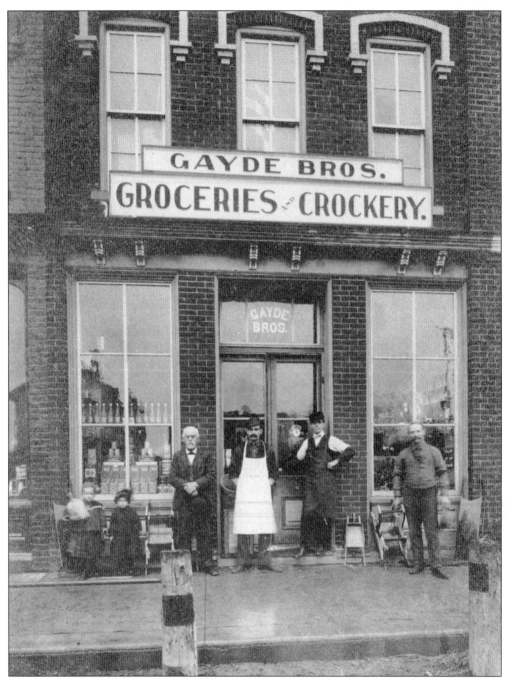

PETER GAYDE (LEFT) AND HIS SONS ALBERT AND EDWARD IN FRONT OF GAYDE BROTHERS GROCERY (second store from left in photo on previous page). The children are Sarah (left) and Helen Gayde, grandaughters of Peter Gayde. The man on the right is unidentified. Peter (1834–1904) came to Plymouth in 1854 as a cooper from Wuerttenberg, Germany. He and 11 other Germans established the first Lutheran Church in Plymouth in 1856. He built this store in 1870–71 and ran the business with his sons. The Plymouth Historical Museum has all of the Gayde Store records.

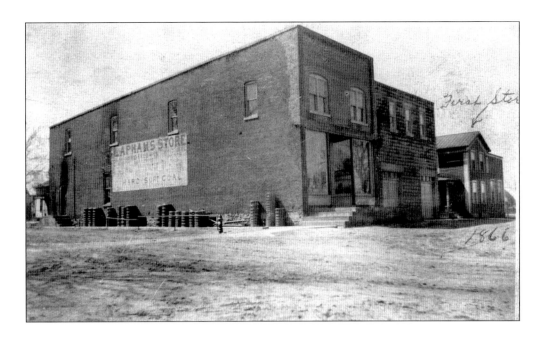

ANDREW JACKSON LAPHAM'S (1841–1927) GENERAL MERCHANDISE STORE IN WHAT IS NOW CONSIDERED PLYMOUTH'S OLD VILLAGE. He opened his first store in 1866 (see above) and later opened a coal and cement business two doors away. The photo below is the inside of Lapham's store.

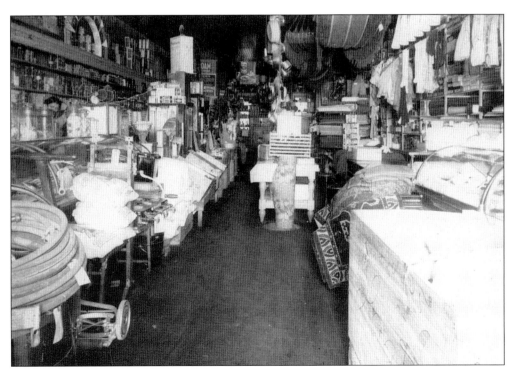

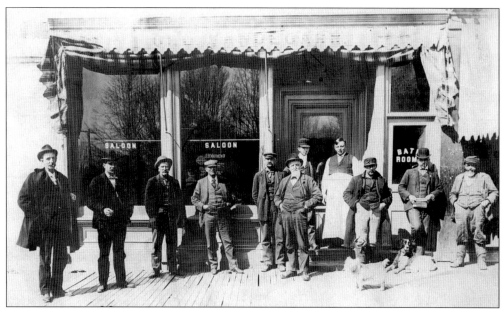

The George VanDeCar Saloon on Main Street Opposite Kellogg Park. The building burned in the big fire of 1893. VanDeCar later became the town barber; his shop was located on the northeast corner of Main and Sutton (now Penniman Avenue) Streets.

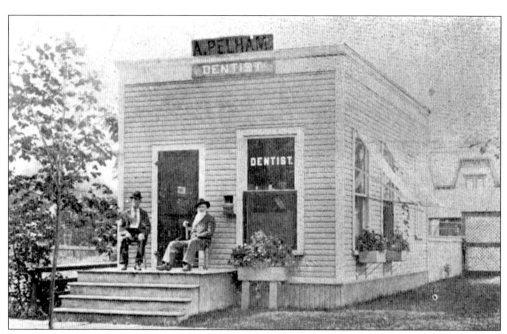

Dr. Abram Pelham's Dental Office on Ann Arbor Road (now Ann Arbor Trail) Opposite Kellogg Park. Pelham (August 15, 1832–February 8, 1921) came to Plymouth in 1856, opened a dental office, and then moved to Kalamazoo County in 1858. In 1860 he enlisted in the 13th Michigan Infantry and served until the close of the war. He returned to Plymouth in 1871 where he again set up his dental practice. Pelham had several inventions patented, including a pneumatic plugger—a dental tool.

OUR BOYS' AND GIRLS'
DRAMATIC
ENTERTAINMENT!

TO BE GIVEN FOR THE BENEFIT OF THE
BAND OF HOPE
AT AMITY HALL,
Friday and Saturday Even'gs, Feb. 13 & 14, '80

Will be presented the beautiful 3-Act DRAMA, entitled:

"THE HOME GUARD."

CAST OF CHARACTERS.

COL. ROWELL	**WILL CONNER.**
Robert Trueworth	Fred Bennett.
Crimp (colored)	Chas. Lailine.
Hosea Jenks	Charlie Bennett.
Hiram Jenks his son	Louie Sherwood.
Gen. Grant	Harry Bennett
Lieutenant Colonel Boxer	Clarence Stevens.
GAYLIE GIFFORD	**MAY BURROWS.**
Mrs. Trueworth	Emma Coleman.
Mattie Trueworth her daughter	Ellen Packard.

To Conclude with the Side-Splitting FARCE, entitled:

ENTERTAINMENT AT AMITY HALL. The performers were often the young people of Plymouth. This program from February 1880 is just one example and includes names of Plymouth natives that heavily influenced the development of Plymouth during their adult years.

MAUD MAXFIELD AND PAUL VOORHIES DRESSED AS TOM THUMB AND WIFE FOR CHURCH ENTERTAINMENT.

FRED HALL (1856–MARCH 1942), TAKEN ABOUT 1880. Hall came to Plymouth in 1862 with his parents (Mr. & Mrs. Richard G. Hall). He clerked in his father's store on Main Street and never married.

THE MILLER-CASSADY HOUSE, A NEW ENGLAND STYLE FARMHOUSE BUILT IN 1875. It is (still) located at 44622 N. Territorial Road but the surrounding land is being developed into condominiums. The home was built by Marcus and Mary Miller on an 85 acre farm inherited from his father, John. It was last owned by Mrs. Norma Cassady.

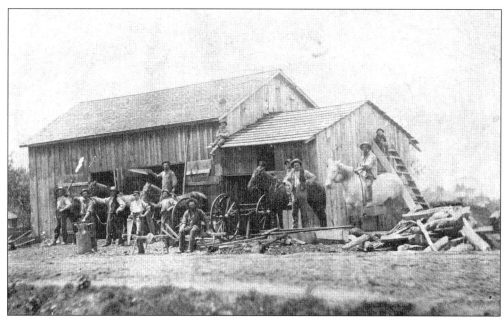

PFEIFFER BARN ON PLYMOUTH PLANK ROAD, ABOUT A QUARTER MILE WEST OF THE ROUGE RIVER.

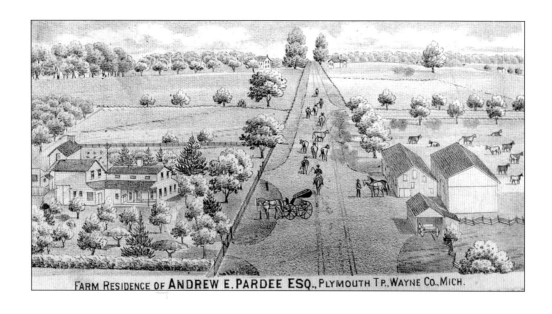

FARM RESIDENCE OF **ANDREW E. PARDEE ESQ.,** PLYMOUTH TP., WAYNE CO., MICH.

TWO OF THE FOUR FARMS LOCATED IN PLYMOUTH TOWNSHIP THAT WERE INCLUDED IN THE
1876 WAYNE COUNTY ATLAS. (Above) Andrew E. Pardee, Esquire (d. November 24, 1877),
had a farm of 80 acres in Plymouth Township. His sons George and Carlos ran the farm after
their father died. (Below) John J. Thompson, Esquire, had his farm in Plymouth Township.

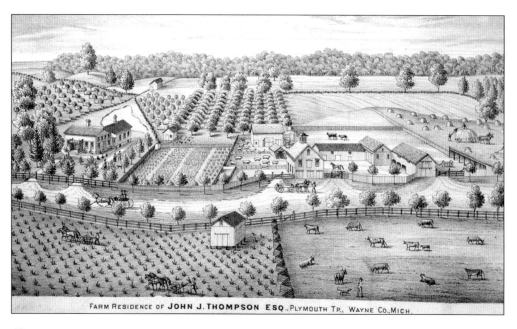

FARM RESIDENCE OF **JOHN J. THOMPSON ESQ.,** PLYMOUTH TP., WAYNE CO., MICH.

Four
1881–1890

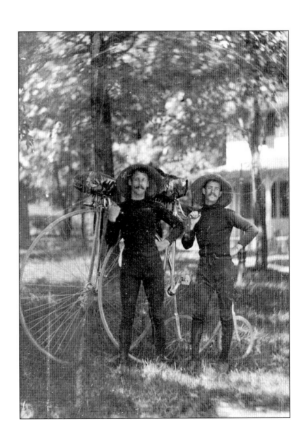

MEMBERS OF THE BICYCLE CLUB OF
PLYMOUTH IN 1889. Possibly Clint
Wilcox (left) and Milton Moore.

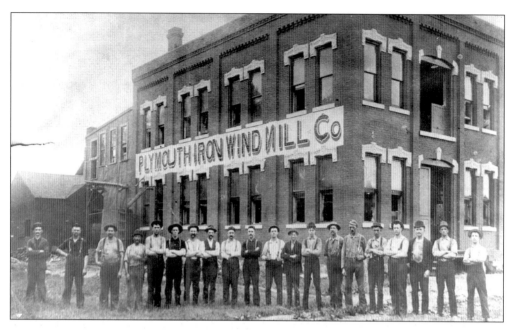

THE PLYMOUTH IRON WINDMILL, INVENTED BY CLARENCE HAMILTON, A WATCHMAKER AND JEWELER, IN 1882. Hamilton raised $30,000 in capital from the citizens of Plymouth and formed the Plymouth Iron Windmill Company, the first stock-held manufacturing company in the area. Henry W. Baker was president, Roswell L. Root was general manager, and Clarence Hamilton was superintendent. This photo is from 1889. During this same year, when the company was about to close from a decline in sales, Hamilton presented the board of directors with the design of an air rifle. Baker is said to have exclaimed, "Clarence, that's a Daisy!" and the Daisy Air Rifle was born. In 1895, the company changed its name to Daisy Manufacturing Company.

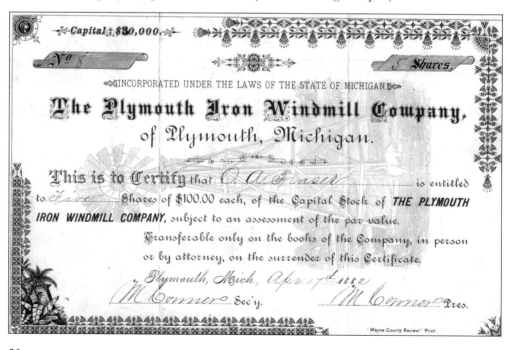

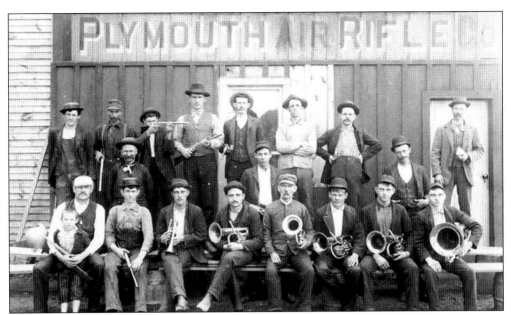

THE PLYMOUTH AIR RIFLE COMPANY, CREATED IN 1888 BY THE SAME CLARENCE HAMILTON (SEE PREVIOUS PAGE) AND CYRUS A. PINCKNEY BASED ON TWO AIR RIFLE PATENTS. The company's building mysteriously burned in October 1894 and, with no insurance, the Plymouth Air Rifle Company ceased to exist. Employees of the company are pictured above. From left to right, seated: first three (including boy) unknown, Henry Tanger, Frank Ray, Charles Halloway, Joe Tessman, Henry Sage, and unknown; standing Dan Smith, unknown, and Pink Stewart. Standing on bench, left to right, unknown, Lew Fisher, Art Burden, Bert Gunsolly, Jim Cooper, unknown, and George Sage.

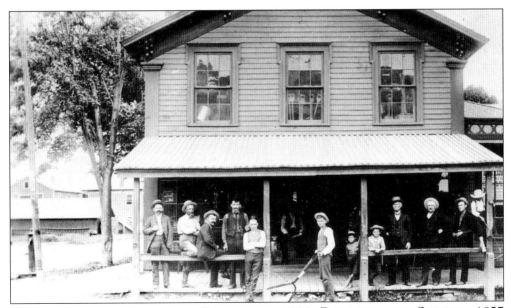

CONNER HARDWARE BUILT THIS BUILDING IN 1884, REPLACING THE ORIGINAL 1857 STRUCTURE. Conner Hardware was a gathering place for local musicians and storytellers as owner Michael Conner fit into both categories.

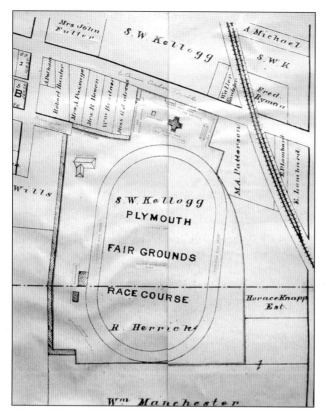

UNIQUE MAP OF THE PLYMOUTH FAIR GROUNDS MADE FROM THE 1893 WAYNE COUNTY ATLAS. The fair was held annually from 1885 until 1904. Not all of the fair's features are indicated on the map. After 1893 it had a merry-go-round, a Ferris wheel, and tented concessions. During the winter following the 1903 fair, the main building, Floral Hall, was destroyed by fire and was not rebuilt. In 1904 the weather was bad and attendance was down. Consequently, the fair was never held again.

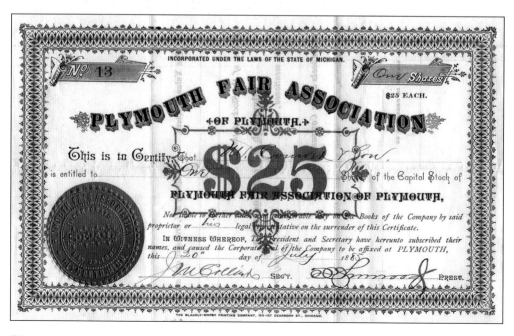

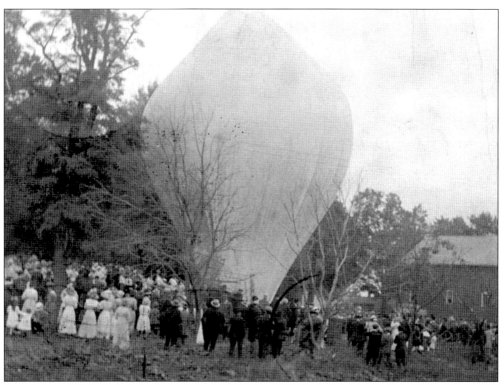

A HOT AIR BALLOON AT THE PLYMOUTH FAIR.

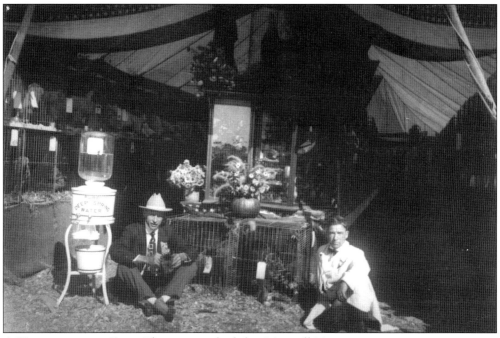

A VENDOR AT THE FAIR. The man on the left is Maxwell Moon.

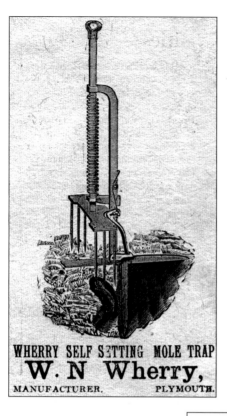

ONE OF PLYMOUTH'S INVENTORS WAS WILLIAM
WHERRY, WHO INVENTED A POPULAR SELF-
SETTING MOLE TRAP. Wherry had operated a
bicycle livery and repair business since 1866 and
was an accomplished taxidermist on the side. His
mole trap was not patented until 1895, about
sixteen years after a *Plymouth Mail* ad appeared
that stated, "Dead shot on moles. If your lawn is
being destroyed by moles, send $2.50 to W. N.
Wherry, Plymouth, Michigan, for one of the above
traps. They are sure to catch them. J. C.
Stellwagen caught 29 in less than one yard of
space." The traps were manufactured in Wherry's
shop on Dodge Street, at the rear of his home on
Main Street. They were shipped all over the U.S.
and Canada. Wherry was still in business as late as
1907.

MANUFACTURING AND
INVENTING WENT HAND-IN-
HAND IN PLYMOUTH DURING
THE 1880S AND '90S. A
gravestone maker, a cheese
factory, the Plymouth Rock
Mineral Springs spring water,
and cigars were among the
items invented or
manufactured here. With the
railroad tracks running
through town, distribution was
not a problem for these
entrepreneurs. George W.
Springer manufactured a line
of cigars named for local
favorites, including the "Hotel
Victor," "The Mail," and the
"Hotel Plymouth." The cigar
box at right contains some of
Springer's cigars called "The
Mail." These cigars and the
box are on display at the
Plymouth Historical Museum.

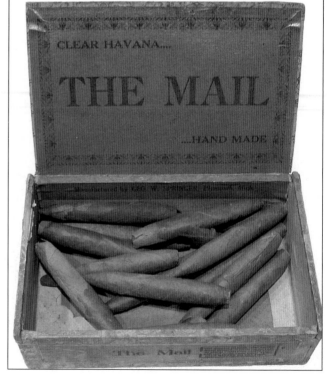

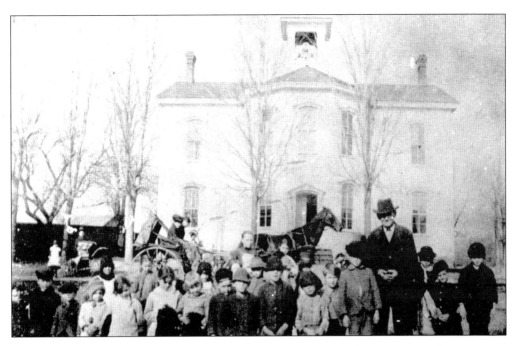

THE FIRST PUBLIC SCHOOL IN THE VILLAGE OF PLYMOUTH. Built in 1840 by E. J. Penniman, the white frame building was given to Plymouth as a memorial to Penniman's wife in 1853. In 1884, the building was purchased by Marvin Berdan and moved to the rear of the Plymouth Hotel and used as a barn. By about 1890, Czar Penney opened up his livery stable (below) using the same old school building.

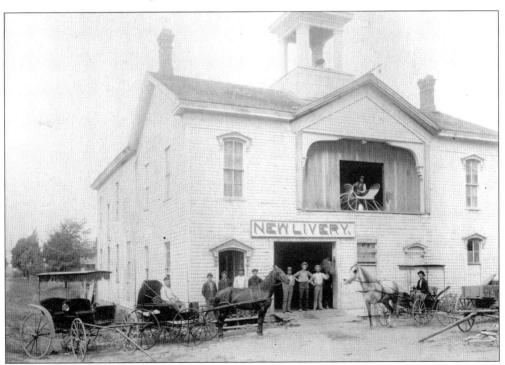

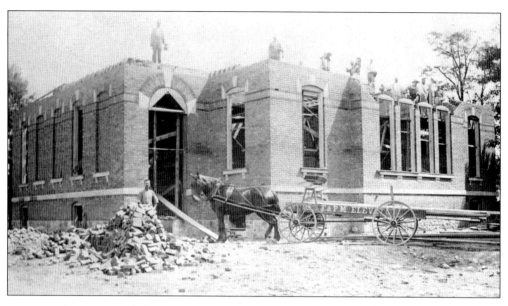

(Above) Plymouth High School (here under construction), Built on Church Street in 1884 to Replace the White Frame Building on the Previous Page. The first superintendent was C. T. Grawn (1881–84).

(Below) The High School and the Methodist Episcopal Church on its Left, before the School was Remodeled in 1907 and the Towers were Removed. Both buildings burned to the ground in March 1916.

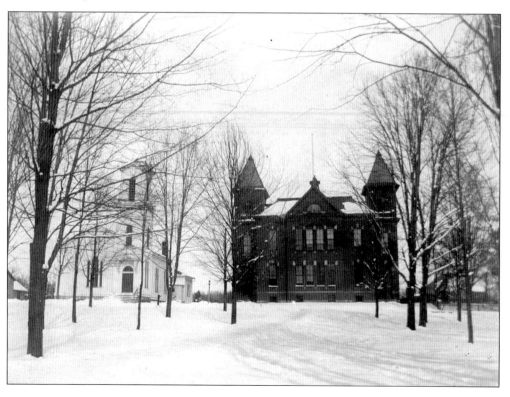

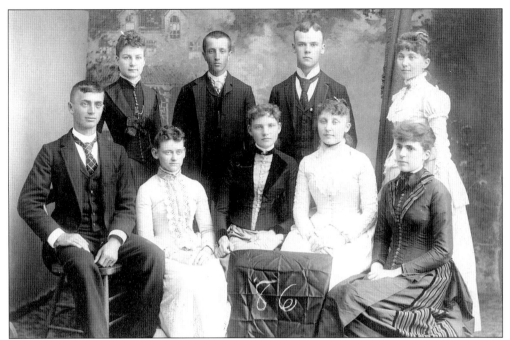

THE PLYMOUTH HIGH SCHOOL CLASS OF 1886. Seated from left to right are Fred Durfee, Mary Conner, Blanche Starkweather, Nellie Berdan, and Maude Vrooman. Standing from left to right are Cara Beam, Irving Durfee, Homer Safford, and Nettie Purdy.

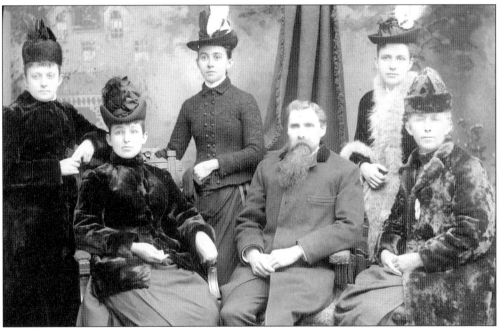

THE PLYMOUTH HIGH SCHOOL TEACHERS IN 1888. Seated from left to right are Delia Entrican, A. C. Brower, and Anna Smith. Standing from left to right are Ella Chaffee, Lina Durfee, and Anna Wildey. Another teacher, Nellie Berdan (pictured above as a graduate in 1886), was sick and was not in the picture.

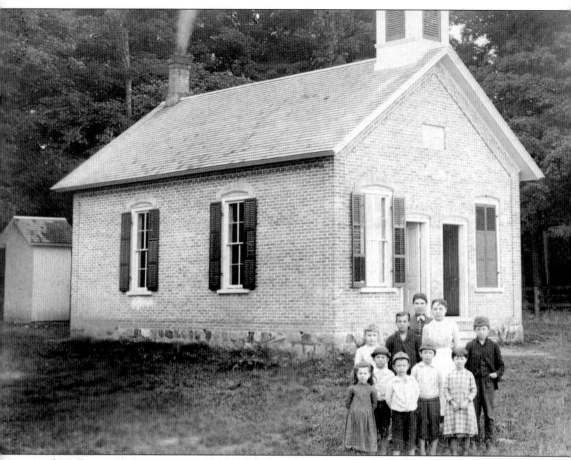

ONE-ROOM SCHOOLHOUSE. A Number of these were Scattered throughout Plymouth Township. The Shuk School House was on the corner of Ridge and Joy Roads. This photo was taken about 1890. The school was later called the Kenyon School.

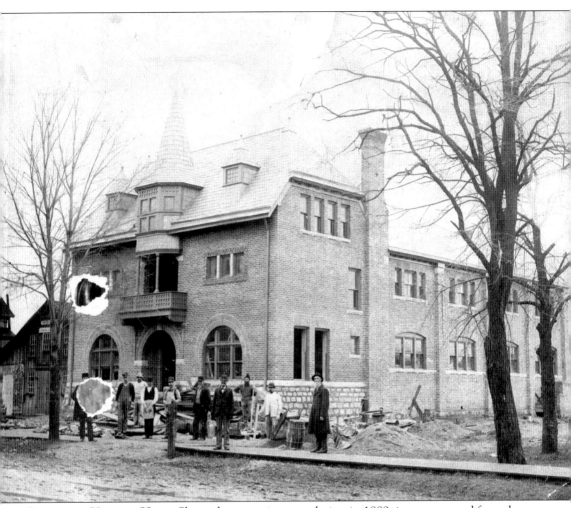

PLYMOUTH VILLAGE HALL. Shown here nearing completion in 1889, it was accepted from the contractors in 1890. It was located on S. Main Street adjacent to where the current City Hall stands today. The Village Hall also contained the new Plymouth Opera House, where many plays and musicals were performed over the years. In addition to civic and cultural events, the hall also hosted commencement exercises, church services, banquets, and band practices.

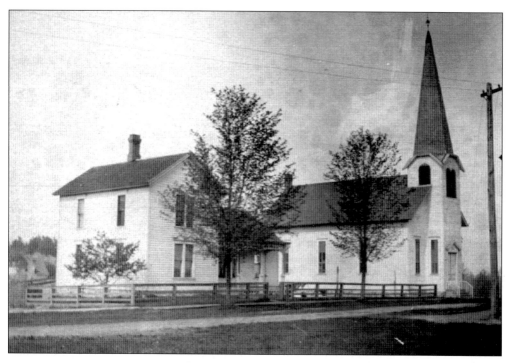

St. Peter's Evangelical Lutheran Church (above). Built in 1883, it replaced an earlier building acquired from the Baptists. The current church building, on the corner of Penniman and Evergreen, was dedicated in 1955. The Presbyterian Parsonage (below) was built in 1886 at 173 S. Union Street. The building now houses apartments.

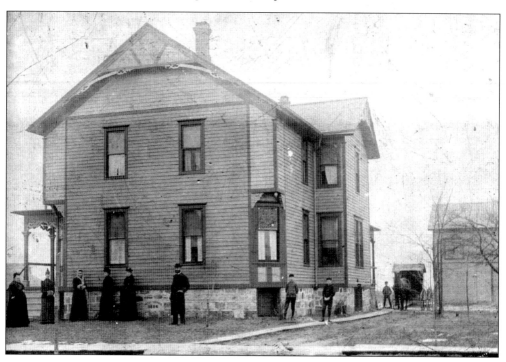

THE HOME CLARENCE HAMILTON BUILT AT 311 HAMILTON STREET (FORMERLY DEPOT STREET) IN 1877. Hamilton lived here with his family and his son Coella's family. Clarence Hamilton invented the Plymouth Iron Windmill and the Daisy Air Rifle, and was founder of three companies: Plymouth Iron Windmill Company (later Daisy Manufacturing Company); Plymouth Air Rifle Company; and Hamilton Rifle Company (with his son Coella).

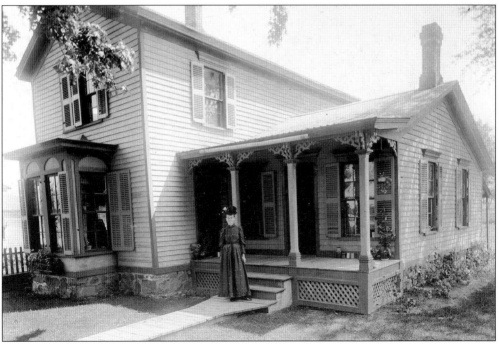

CYRUS A. PINCKNEY'S HOUSE AT 556 MILL STREET CIRCA 1890. Pinckney was cofounder and president of the Plymouth Air Rifle Company, with Clarence Hamilton.

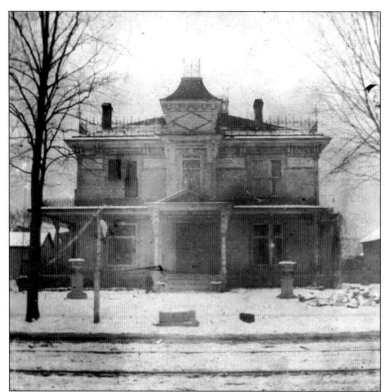

JOHN KELLOGG, SON OF PIONEER LANDOWNER JOHN KELLOGG, LIVED AT 223 S. MAIN STREET IN THIS HOME LATER OCCUPIED BY E. R. BAKER AND FRANK PARK AS A DOUBLE HOUSE. The block in front of the house, near the street, was used to alight from a carriage. In later years, the home housed the library, until it was razed for a modern brick building.

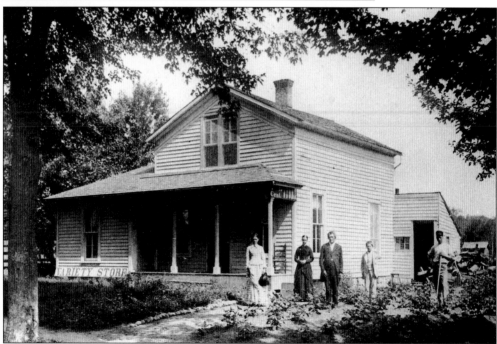

THE JAMES ROLLIN HOUGH HOUSE AT 736 CHURCH STREET CIRCA 1890. From left to right are Ann I. Hough Wright (daughter), Julia M. Hayward Hough (wife), James Rollin Hough, and Ira D. and Plato B. Hough (sons).

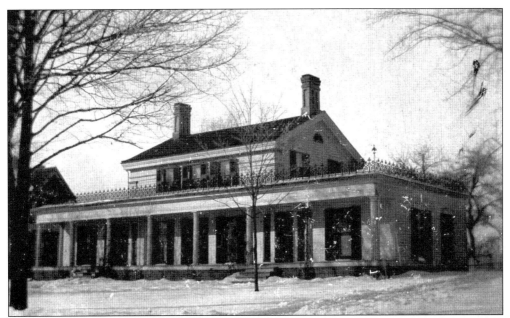

THE HOME HENRY BENNETT BUILT AT 243 N. MAIN STREET IN 1885. In about 1890 he sold the house to Lewis Cass Hough, treasurer and then general manager of Daisy Manufacturing Company (until his death in 1902) and owner of Plymouth Elevator Company. Hough's son Edward remodeled the house in Southern Colonial style in 1905; the house burned to the ground in 1963 (see page 92).

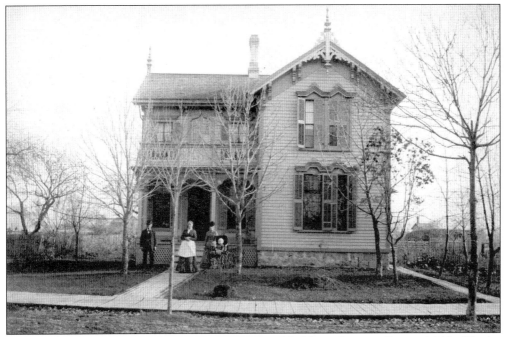

THE HOME OF JAMES AND MARY PARK AT 134 N. MAIN STREET CIRCA 1882. Charlie Bennett, president of Daisy Manufacturing Company 1920–56, lived here after the Parks. The house still stands. (Photo courtesy of Garry Packard.)

A HOME AT 218 S. MAIN STREET, BUILT IN 1890 BY THOMAS PATTERSON IN THE VICTORIAN QUEEN ANNE STYLE. In 1932, the building became the Plymouth Hospital, run by nurses Lena and Alma Weist. The hospital was open until 1966. It is now used as a commercial building.

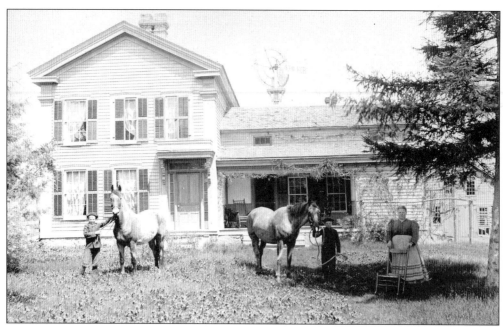

A FARM HOUSE ON ANN ARBOR TRAIL (FORMERLY ANN ARBOR ROAD) NEAR HAGGERTY ROAD IN PLYMOUTH TOWNSHIP. The house was once owned by Ambrose Burr. Pictured from left to right are Burt Tomlinson, Harry Tomlinson, and their mother. The house is still standing.

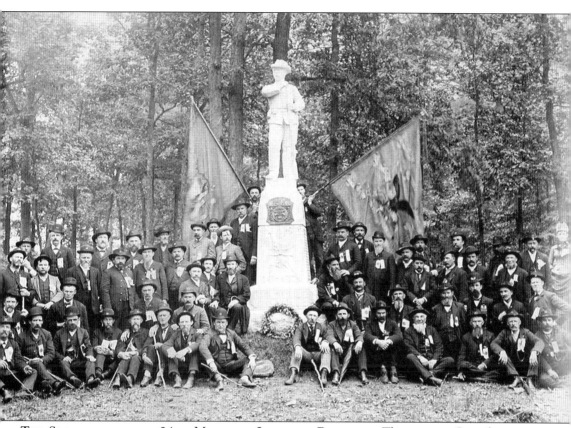

THE SURVIVORS OF THE 24TH MICHIGAN INFANTRY REGIMENT. They met in Gettysburg, Pennsylvania, June 12, 1889, to dedicate the monument to the 1st Iron Brigade, 1st Division, 1st Corps, of which the 24th Michigan was a regiment. Many Plymouth residents were included in the group of survivors.

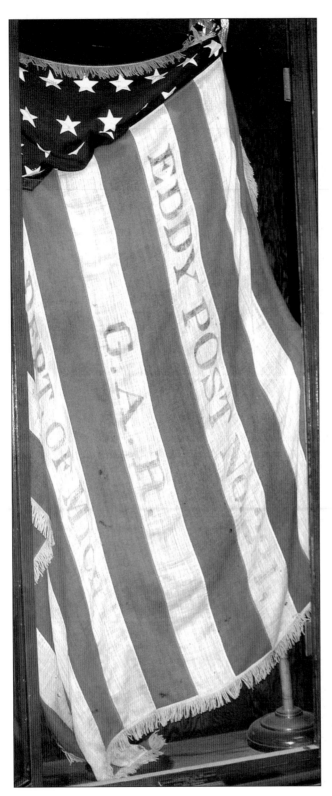

THE GRAND ARMY OF THE REPUBLIC (GAR), A SERVICEMEN'S ORGANIZATION OF CIVIL WAR VETERANS WHO FOUGHT FOR THE UNION. It was organized in Decatur, Illinois, on April 6, 1866. The first Michigan chapter was formed the following year; Plymouth's Eddy Post #231 was formed in 1884 and was named for the Eddy brothers—Clark Eddy died of disease while serving with the 24th Michigan Infantry Regiment. Most of the members of the GAR were Republicans and the organization became a powerful pressure group, fighting successfully for pensions and other benefits for the veterans. The Eddy Post flag was presented to the Village of Plymouth in the 1930s.

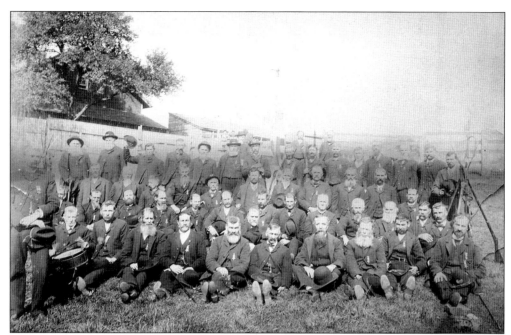

MEMBERS OF PLYMOUTH'S EDDY POST 231, GRAND ARMY OF THE REPUBLIC. While the identities of these men shown in this 1891 photograph are not known specifically, the muster roll for the post in June 1884 (shortly after it formed) listed the following as members, A. O. Lyon, S. S. Lyon, Albert Stevens, Melville R. Weeks, John N. Dodge, Ralph Terry, Abram Pelham, T. V. Quackenbush, John Haywood, A. N. Brown, John E. Hood, C. E. Baker, R. L. Root, Jacob Lyon, Oliver Westfall, Ralph Ria, C. H. Grant, Akins Holloway, John Gill, Fred Smith, Henry Walker, William Grant, John Elenbush, Charles Durfee, William Smitherman, Daniel Smith, Henry Robison, J. Cramer, Morris Smith, Henry Hoisington, George S. Wheller, Jerome Pierce, Joseph Tessman, and C. R. Crosby.

CZAR PENNEY IN 1889. He was in the livery stable business from about 1890 to 1921. His first location was in the old school house (see page 55) that was moved to the rear of the Plymouth Hotel. Then he built a large barn on Starkweather Avenue and later moved it to S. Main Street, just south of Ann Arbor Road (now Ann Arbor Trail). He also built a house next door to the relocated barn.

67

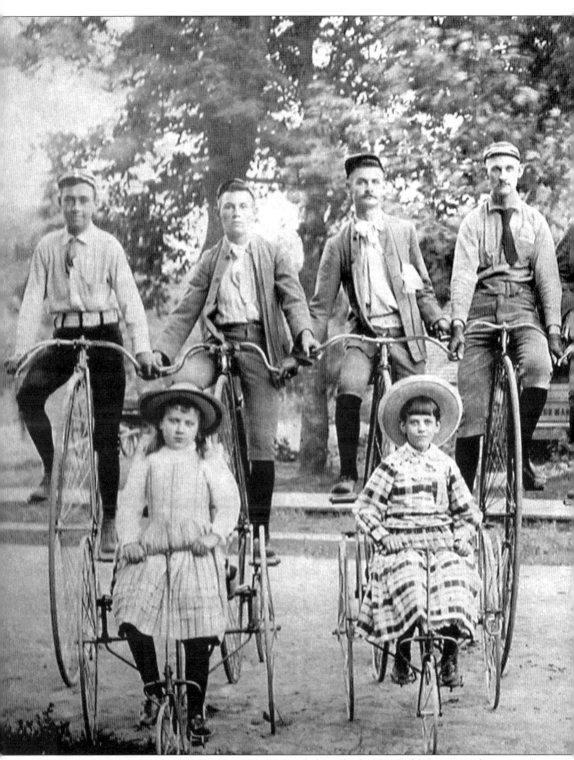

BICYCLE CLUB OF PLYMOUTH IN 1889. From left on high-wheeled bikes are Edison Huston, Ed Bennett, Milton Moore, Shil Tafft, Lou Sherwood, Clint Wilcox, George VanDeCar,

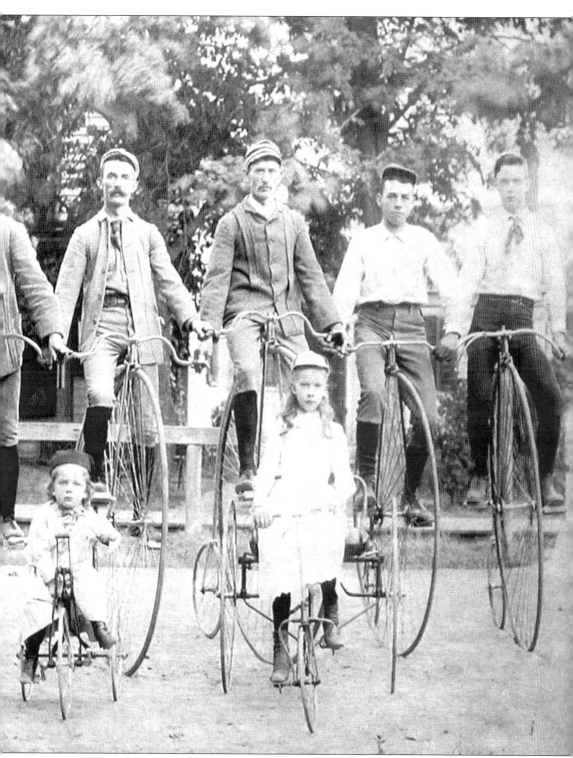

Arthur Huston, and Hop Shaffer. On tricycles from left are Babe Penniman, Zetta Tindale, Freddie Burnett, and Maude Millspaugh.

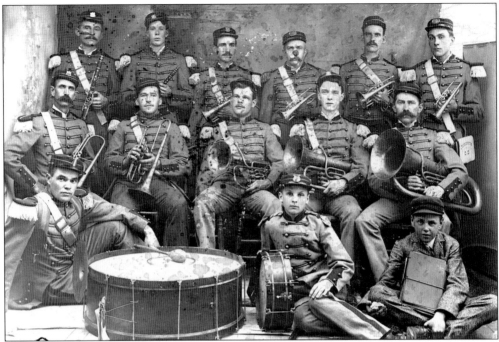

THE PLYMOUTH CORNET BAND ABOUT 1890. Harry Robinson is at the lower left and Charles Halloway is above him with the trombone. At the far right in the middle row is Charles Bennett, son of Washington Bennett (not related to the Charles Bennett who became president of Daisy).

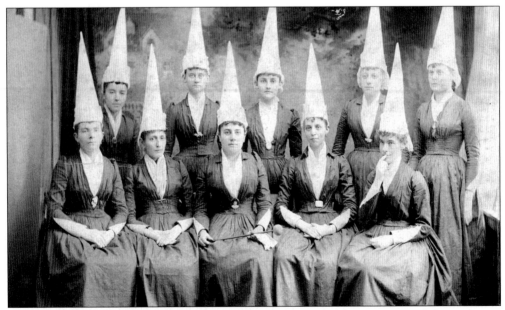

THE "PEEK SISTERS" CAST, WHICH PERFORMED AT AMITY HALL IN 1890. From left to right are, seated; Anna Tafft; Lusina Robinson; Kate Penniman Allen; Carrie Hillmer; and Sarah Cook; standing, Carrie Peck Bennett; Mamie Conner; Emma Coleman; Nettie Pelham; and Nellie Steele.

Five

1891–1900

WILLIAM F. "PHILIP" MARKHAM
(1851–APRIL 30, 1930) LEFT HIS
MARK ON THE PLYMOUTH
COMMUNITY. A maker of wooden
tubs and cisterns, he built a model
of the first air rifle and convinced
Elmer Chaffee to sell his half of a
grocery store to partner with
Markham. The Chicago Air Rifle,
the first in a long line of air rifles,
became popular overnight.
Markham had a troubled personal
life, however, and in 1894 his wife
Carrie moved to Detroit with his
three children. When his oldest son
Harry died the next year, Markham
dealt with his grief by working
harder and becoming more
successful.

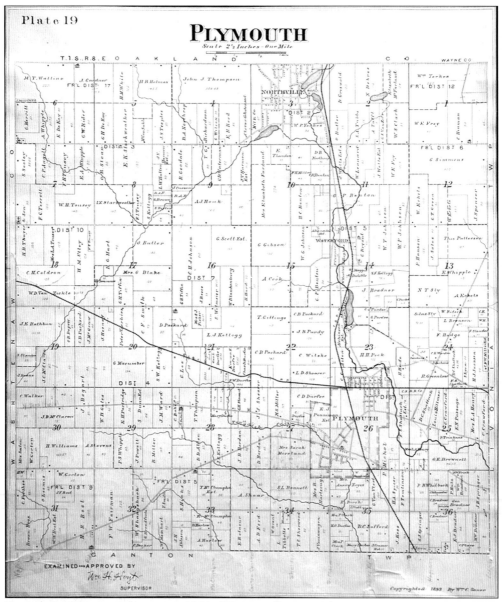

PLYMOUTH TOWNSHIP IN AN 1893 WAYNE COUNTY ATLAS, SHORTLY BEFORE THE
TOWNSHIP WAS SPLIT IN HALF WITH THE NORTH HALF BECOMING NORTHVILLE TOWNSHIP
IN 1898.

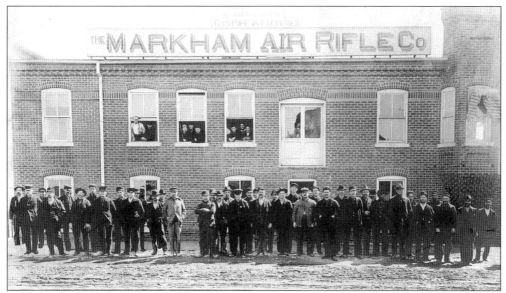

The Markham Air Rifle Company c. 1900, with Employees Pictured Outside. The building was (and is) immediately adjacent to the north side of the railroad tracks on N. Main Street. The building still stands and has been converted into a number of commercial concerns. (Below) Markham employees in the second floor woodworking shop. The Markham Manufacturing Company was originally formed for the manufacture of tanks and cisterns of all kinds. In August 1887, Philip Markham procured a patent on an air rifle, of which large numbers were made. In 1888, the air rifle was shipped all over the world and the plant employed 25 men.

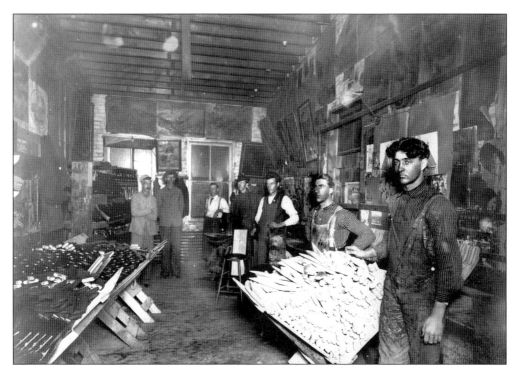

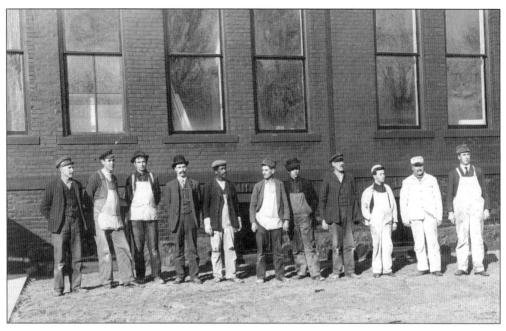

(Top) **Workers at Daisy Manufacturing Company, formerly known as the Plymouth Iron Windmill Company.** In 1895, Daisy was producing 100 air rifles a day, with the factory in production twelve and a half hours daily, and back orders for 300 rifles.
(Bottom) **Daisy's Assembly Plant.**

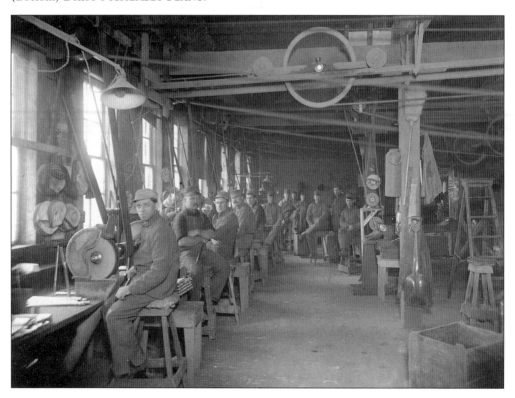

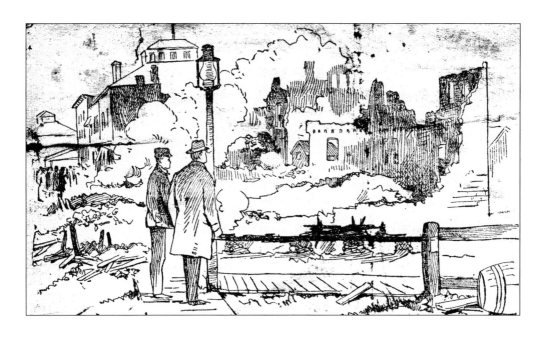

THE MAIN BUSINESS BLOCK ON S. MAIN STREET, WHICH BURNED TO THE GROUND—FOR THE SECOND TIME—IN 1893. The scene was captured in a woodcut engraving in the *Plymouth Mail* later that week. The citizens of Plymouth had voted to bring a water line into town, but the process hadn't been completed at the time of the fire. Some of the volunteer bucket brigade that helped put out the fire are pictured below.

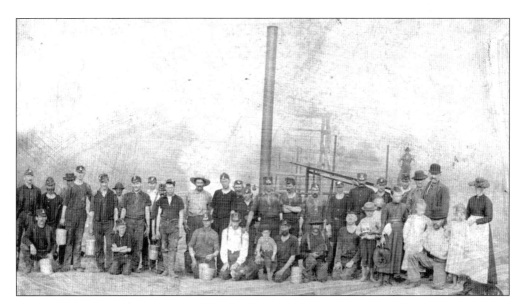

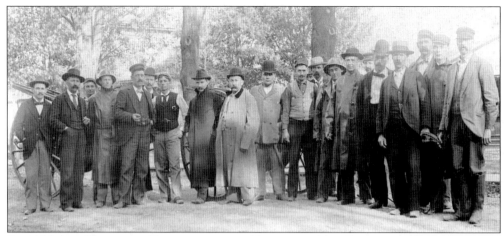

By 1895, the Village of Plymouth had a Volunteer Fire Department and a Water Supply Pumped in from the Township.

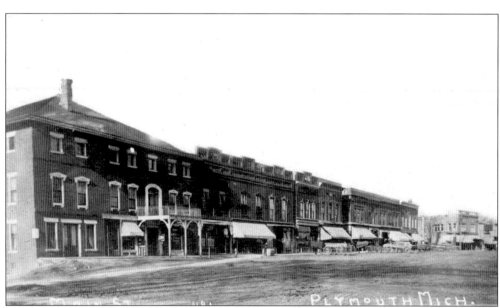

Rebuilt after the Devastating Fire of 1893, the Main Business Block was Revived with Brick Buildings. Most of the northern half of the block still stands in the year 2002. The southern half was torn down by the S. S. Kresge Company in the 1950s. This postcard was taken about 1900.

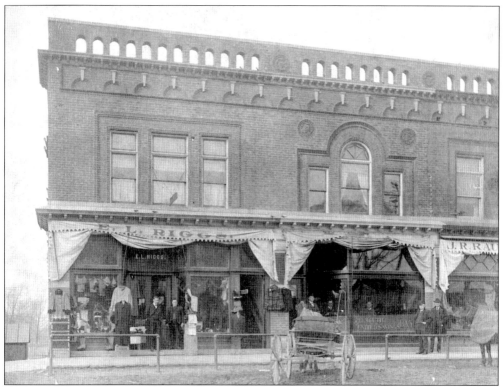

The North Half of the Main Business Block on S. Main Street in 1900. Businesses on the block included Riggs, Plymouth United Savings Bank, and Rauch's Dry Goods.

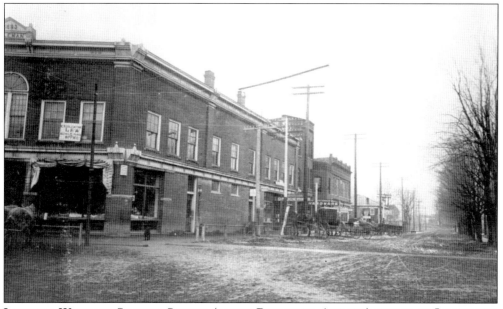

Looking West on Sutton Street (later Penniman Avenue) where it Intersects with Main Street. The Coleman building on the corner housed A. H. Dibble & Son Shoes & Clothing and John L. Gale Drugs and Groceries.

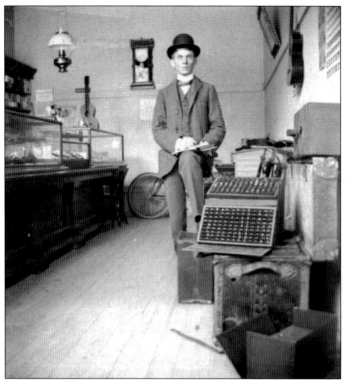

CHARLES DRAPER (D. JANUARY 1941) IN HIS JEWELRY AND WATCH STORE ON MAIN STREET ABOUT 1900. Draper was also an amateur photographer and took many of the photos that represent Plymouth at the turn of the twentieth century.

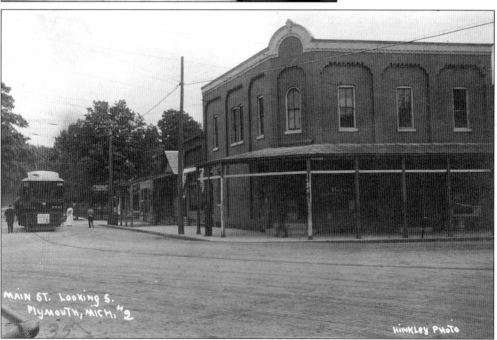

LOOKING NORTH (NOT SOUTH AS THE POSTCARD SAYS) ON MAIN STREET AS THE INTERURBAN TRAIN APPROACHES. The Interurban ran between Northville and Detroit and stopped in Plymouth. It operated between 1898 and 1924. Peter Gayde built the large brick building on the right at the corner of Main and Sutton Streets (now Penniman Avenue).

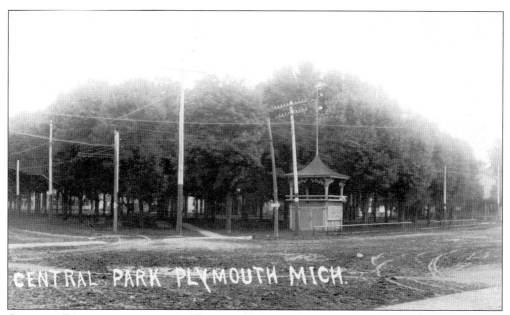

CENTRAL PARK, NOW KNOWN AS KELLOGG PARK, IS OPPOSITE THE MAIN BUSINESS BLOCK ON S. MAIN STREET. The park was donated to the village by pioneer John Kellogg. The viewing stand was used for parades and other events. The park is a lot less wooded now but is still a focal point of city life in Plymouth.

THE DETROIT, PLYMOUTH & NORTHVILLE RAILROAD (OR THE "INTERURBAN") RAN BETWEEN 1898 AND 1924. It allowed for greater passenger service between Plymouth and Northville and Plymouth and Wayne, where passengers changed trains for Detroit. Fares were 10 cents between Plymouth and Northville and 15 cents between Plymouth and Wayne. In the map on the right, the route is shown as a dark line running north from Wayne, through Plymouth, to Northville.

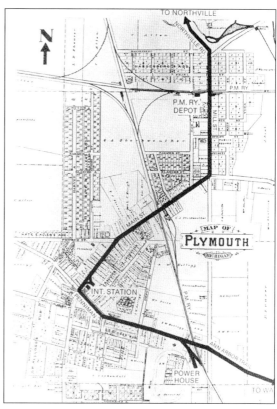

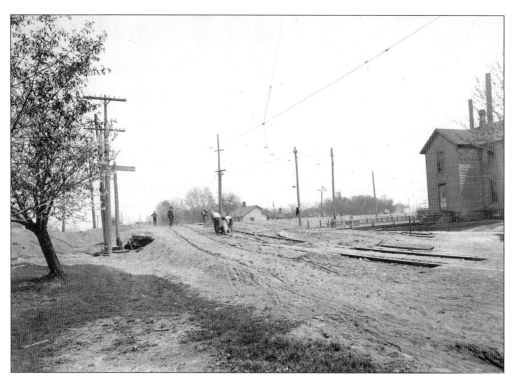

(Above) **ANN ARBOR ROAD (NOW ANN ARBOR TRAIL) LOOKING EAST.** The roads were still dirt then, and men are laying the ties and track for the Interurban in 1898. At the top of the hill is the crossing for the Pere Marquette Railroad tracks. The home on the right belonged to Melvin and Phoebe Patterson (see page 113).

(Below) The Interurban Car is parked on the trestle over the Rouge River. The motorman and the conductor are in uniform. The horse and buggy (with top down) are heading for Plymouth on the adjacent bridge.

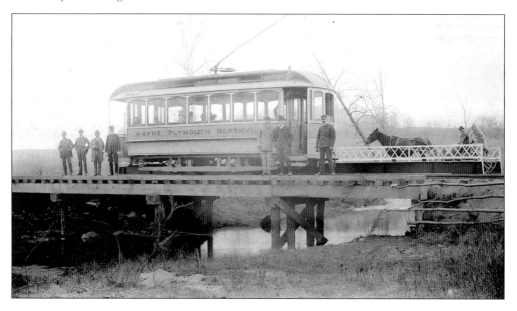

A PERFORMANCE ON THE STAGE OF THE PLYMOUTH OPERA HOUSE, WHICH WAS PART OF VILLAGE HALL ON MAIN STREET. Entertainment of any kind was welcome in Plymouth and the Opera House was in constant use.

6th Annual Operetta

Plymouth Opera House,

Friday Ev'g, Mar. 1

Yᵉ Little Oldᵉ Folks' Concert

With much music such as ye big folks did sing betimes, at ye last meeting of ye same. Likewise, here will be some Gay and Pretty Songs, not too worldly, but yet—

LIKEWISE, ALSO, MUCH MERRY TALK

————BY————

POLLY SIMPKINS.

150 SINGERS 150

High School Glee Clubs will Sing

Admission, - 15 and 25 cts.

RESERVED SEATS 10 CENTS EXTRA.

Tickets on sale at Wolverine Drug Store.

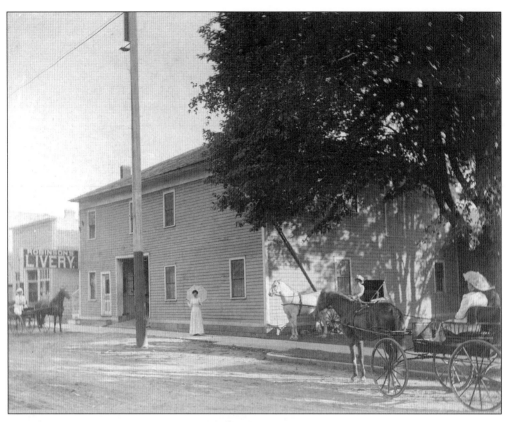

(Above) Light Traffic on Sutton Street (now Penniman Avenue) in Front of Robinson's Livery. (Below) Rush Hour on North Main Street. The best way to get around Plymouth at the turn of the century was still on a horse-drawn carriage.

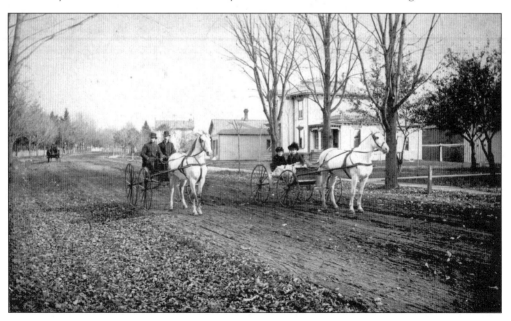

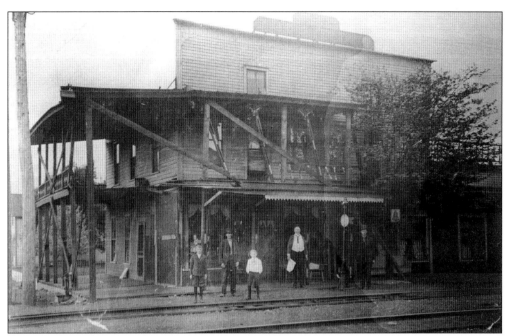

DAN SMITH'S COFFEE SHOP AND HOTEL BY THE PERE MARQUETTE TRAIN STATION ON STARKWEATHER ROAD. The man with the vest is Dan Smith. The boy on the left is Milton Laible and the one with the white shirt is Frank Pierce.

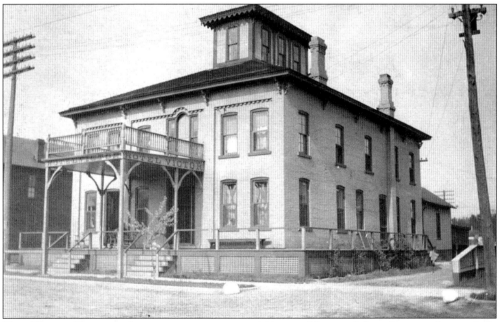

THE HOTEL VICTOR, OPENED DURING THE 1880S ON NORTH MILL STREET. It primarily served railroad passengers and workers for much of its history. The hotel was renamed the Hotel Anderine between 1925 and 1927. The Sambrone family ran the hotel for about 60 years. It changed hands several times and was also known as the Nelson Hotel and the Old Village Inn. The building burned down in the 1980s.

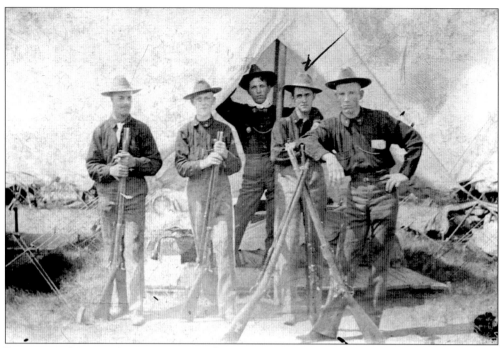

PLYMOUTH NATIVE ARTHUR BRIGGS (SECOND FROM RIGHT) TRAINING AT CAMP EATON, ISLAND LAKE, MICHIGAN DURING THE SPANISH AMERICAN WAR. (Photo courtesy of Garry Packard.)

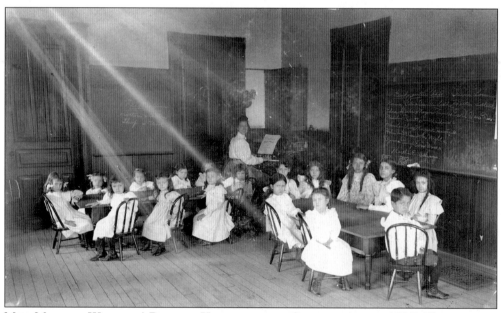

MISS MARTHA WILLIAMS' PRIVATE KINDERGARTEN CLASS IN ABOUT 1897. There was no kindergarten in public schools until 1900.

DR. ALBERT PATTERSON (D. 1935), SON OF DANIEL PATTERSON AND BROTHER-IN-LAW OF FRED SCHRADER, THE FOUNDER OF SCHRADER FUNERAL HOME. Dr. Patterson was at one time the only doctor in Plymouth. The painting was made in about 1900.

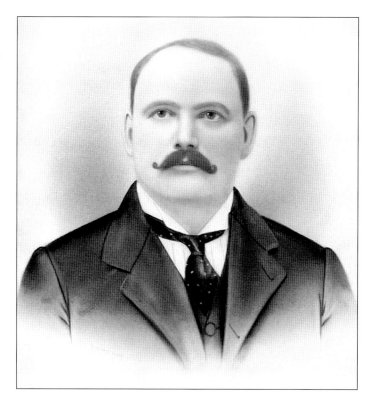

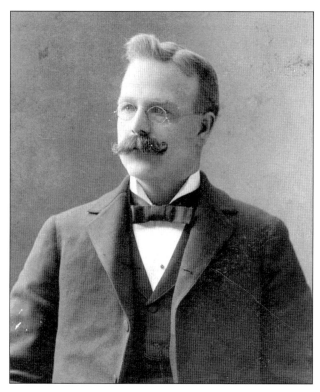

MEDICAL DOCTOR FRED TILLAPAUGH HAD AN OFFICE ON S. MAIN STREET WHERE SCHRADER FUNERAL HOME STANDS TODAY.

CHARLES H. BENNETT (JUNE 27, 1863–SEPTEMBER 17, 1956). He began his business career peddling wheat fanning mills for his father (see photo below). In 1888 he began exchanging air rifles for lodging while he was on the road peddling. As air rifle sales grew, he went to work for the Plymouth Iron Windmill Company (later Daisy Manufacturing Company) and became an officer of the company. He introduced the air rifle into every civilized country in the world, except Russia. Bennett became president of Daisy in 1912, following the death of H. W. Baker. He held the position for 44 years, until his death at age 93. The photo was taken about 1900.

L. H. BENNETT (FATHER OF CHARLES H. BENNETT ABOVE). He took over sole ownership of the Fanning Mill factory after the death of his brother C. H. Bennett. Charles Bennett wrote that the factory at one time "had a grand total of 15 men on its payroll. Work started at 7 a.m. and continued to 6 p.m. No bonuses, no vacations, no division of profit."

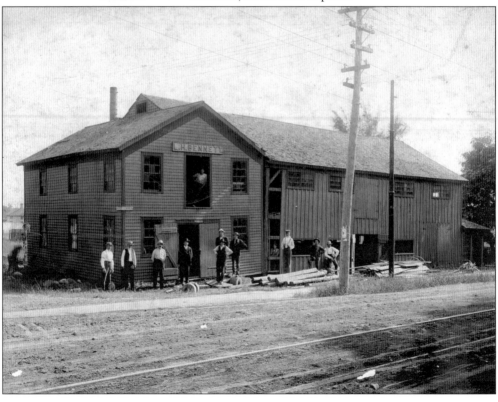

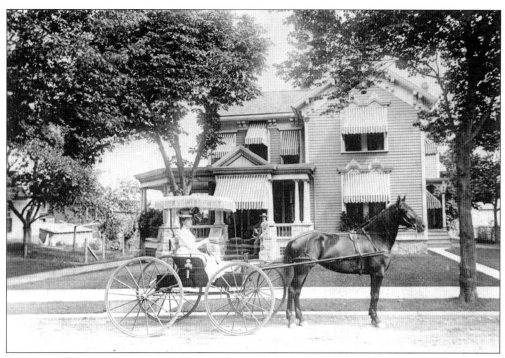

CHARLES H. BENNETT, SITTING ON THE STAIRS OF HIS HOME AT 134 N. MAIN STREET. His wife, Carrie Peck Bennett, is in the phaeton with Prince in the harness. The house, still standing, is almost opposite the Plymouth High School (now Central Middle School).

CLARENCE STEVENS (NOVEMBER 23, 1865–1968), A PIANO TUNER IN PLYMOUTH FOR ABOUT 47 YEARS. It was a career that he started in his late 50s because he wasn't making enough money teaching voice and piano. He retired at the age of 98 and lived to be 103. He graduated from Plymouth High School in 1882 and spent a year at Ypsilanti Normal School (now Eastern Michigan University) to become a music teacher. He gave private lessons in the Plymouth area for many years. His father, Arthur Stevens, a Civil War veteran (see page 29), lived to be 95 years old and his mother, Agnes Sawyer Stevens, lived to be almost 90.

(Top) THE THOMPSON CHILDREN FOLLOWING THEIR BAPTISMAL SERVICE AT THE METHODIST EPISCOPAL CHURCH IN PLYMOUTH. Reverend W. G. Stevens officiated at the baptisms of, from left, Myra B. (34 months), Thomas B. (22 months), and Alberta (46 months), children of T. J. and Laura Thompson of North Territorial Road.

(Left) LAURENCE B. SAMSEN, ON THE LEFT, AND HIS BROTHER RALPH SAMSEN. Their father, F. W. Samsen, owned the *Plymouth Mail*, the only newspaper in Plymouth for many years. Laurence edited the paper. The paper is now called the *Plymouth Observer & Eccentric*.

BESSIE I. RATTENBURY DUNNING (JULY 29, 1871–OCTOBER 24, 1956). She was Raised on the Rattenbury Farm (below). It was located on the south side of Plymouth Road between what are now Merriman and Middlebelt Roads (now the Rosedale Gardens subdivision in Livonia, Michigan). William Rattenbury (back right) was a large landowner in what was then called Nankin Township. His son William is in the back left of the photo. Bessie married Charles A. Dunning (d. 1923), who was also a large land owner in Plymouth and Redford Townships. They had one daughter, Margaret, who had a long, successful business career, continues to serve on the Board of Directors of the Plymouth Historical Museum, and has twice endowed the museum with the money to expand in what is now the Dunning Memorial Building.

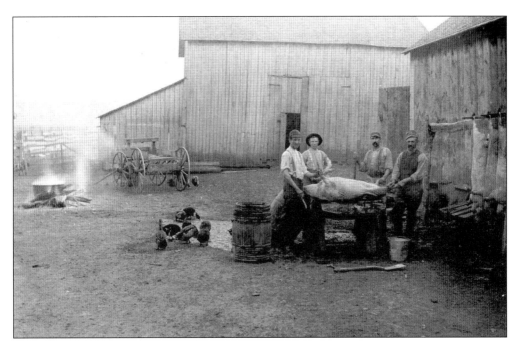

THE HOME AT 932 SUTTON STREET (NOW PENNIMAN AVENUE), OWNED BY DR. FRANK B. ADAMS (OCTOBER 15, 1854–FEBRUARY 1928). Dr. Adams and his family are relaxing on the porch and their horse "Clyte" can be seen in the back of the driveway. In the rear of the Adams' home (below), Mrs. Burden was washing the family's clothes. At the turn of the century, there was no running water; they used cistern water for laundry work and pump water for drinking. The toilet facilities were in the barn.

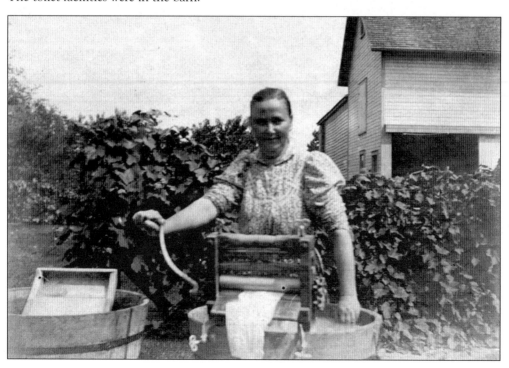

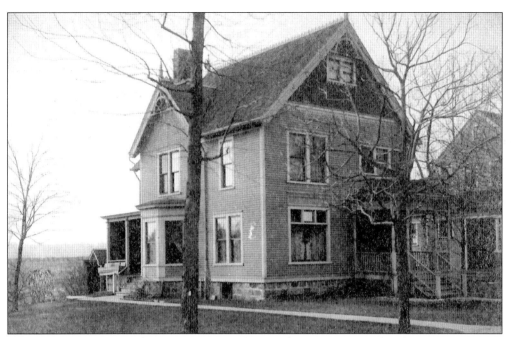

1103 Sutton Street (now Penniman Avenue), Home of Mary Conner and her Mother in about 1900. The house still stands.

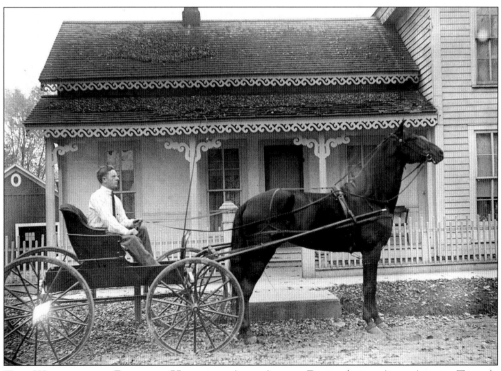

The Washington Bennett Home on Ann Arbor Road (now Ann Arbor Trail), near Deer Street. The driver is Pierre Bennett, Washington's grandson. This house was torn down to create a parking lot for Saxton's Garden Center.

EDWARD C. HOUGH'S HOUSE AT 243 N. MAIN STREET. It was built by Henry Bennett in about 1885 (see page 63). The house burned down in 1963. Hough (1872–1959) followed Charles H. Bennett as president of Daisy Manufacturing Company from 1956 until his death in 1959. Daisy moved to Rogers, Arkansas, in 1958, shortly before Hough's death.

Six

1901–1910

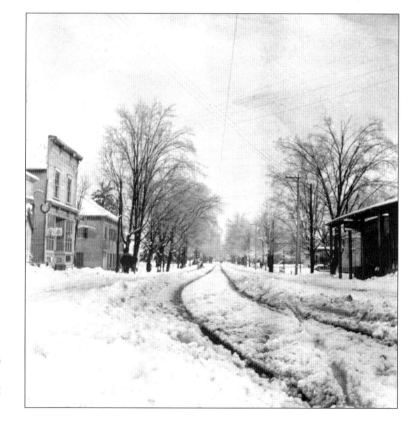

S. Main Street, just North of Sutton Street (now Penniman Avenue) following a major Snow Storm in January 1904. The Interurban trains were able to get through using plows on the front end of the cars.

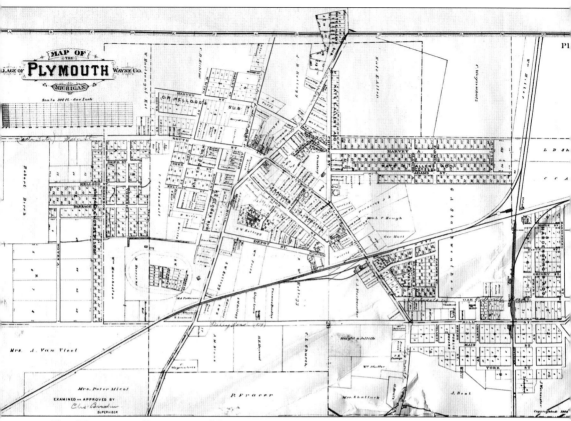

THE VILLAGE OF PLYMOUTH, MICHIGAN, IN 1904, SHOWING THE NAMES OF LANDOWNERS.

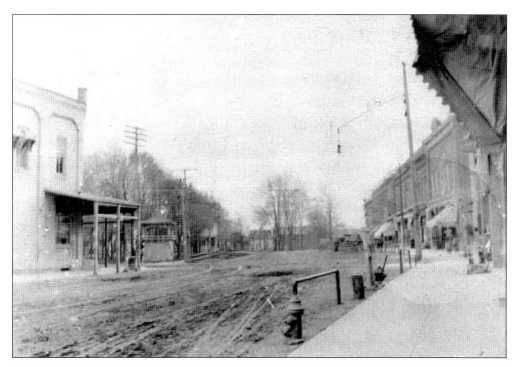

(Top) **Looking South on S. Main Street in 1904.** Kellogg Park is on the left and the main business block is on the right.

(Bottom) **Looking North on S. Main Street in 1905 on Market Day.** The horses are all parked in front of the central business block.

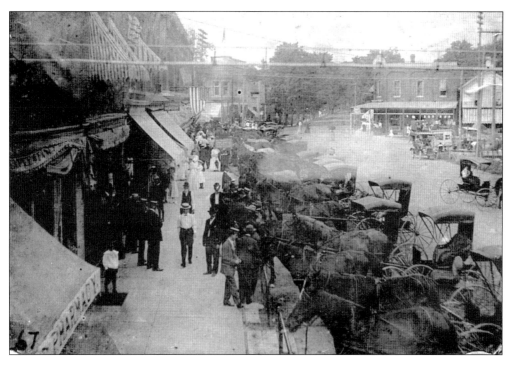

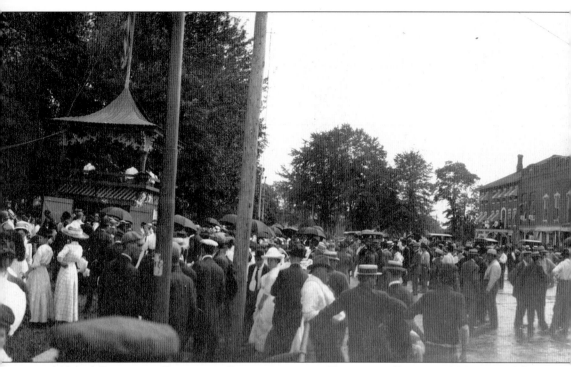

(Above) **PLYMOUTH RESIDENTS CELEBRATING THE FOURTH OF JULY IN 1909 IN THE MAIN BUSINESS DISTRICT ON S. MAIN STREET.** Kellogg Park and the viewing stand are on the left.

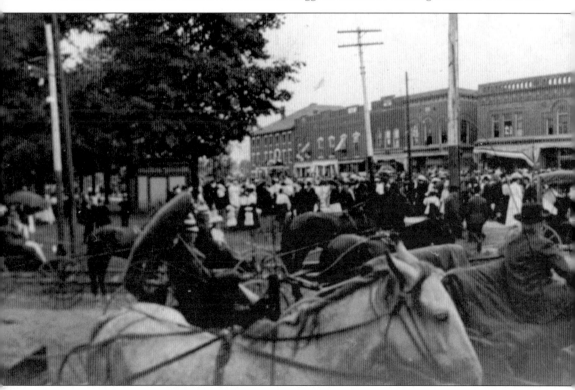

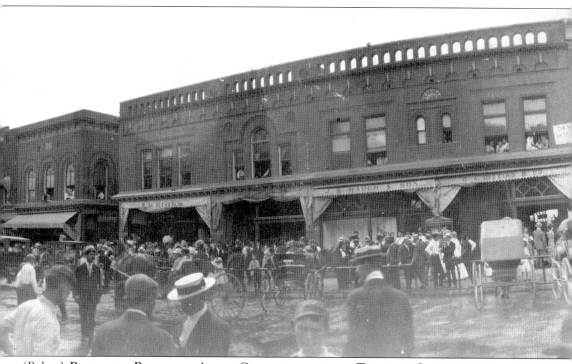

(Below) PLYMOUTH RESIDENTS AGAIN CELEBRATING—THIS TIME THE CELEBRATION WAS CALLED "HORSE AND BUGGY DAYS."

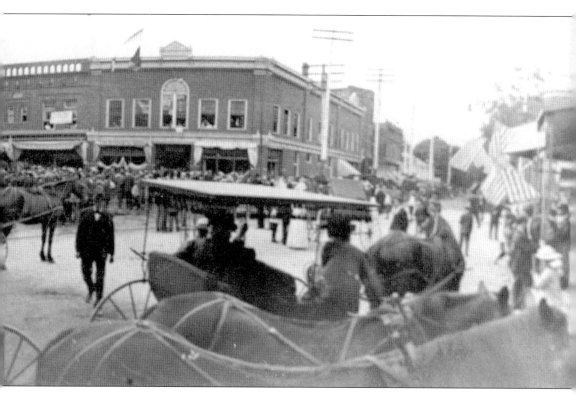

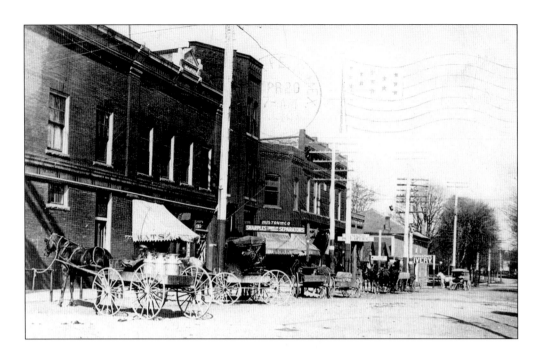

Sutton Street (renamed Penniman Avenue in 1912) looking West (top photo) and looking East (bottom photo). The top photo was taken shortly after the turn of the century when horse and buggy still predominated. The Plymouth Post Office and Robinson's Livery can be seen at the end of the block of buildings. By the time the bottom photo was shot, in about 1910, the new "horseless" carriage had started to become popular in Plymouth.

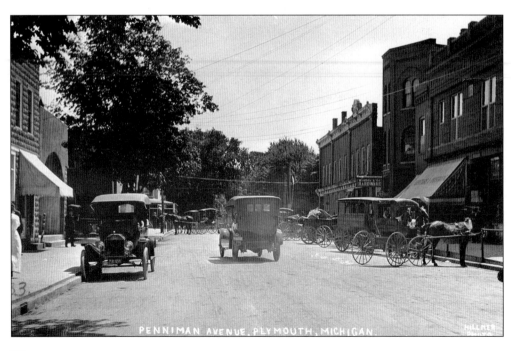

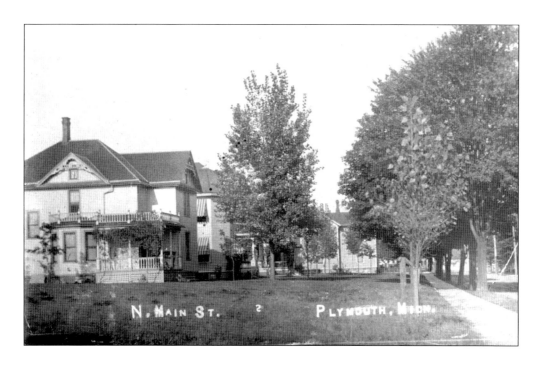

NEIGHBORHOODS BEGINNING TO GROW IN THE VILLAGE OF PLYMOUTH AFTER THE TURN OF THE CENTURY. (Above) Some of the houses in the more affluent residential section of North Main Street, with trees lining the road. These trees were removed to widen Main Street later in the century. (Below) North Harvey Street parallels and is the first street to the west of Main Street.

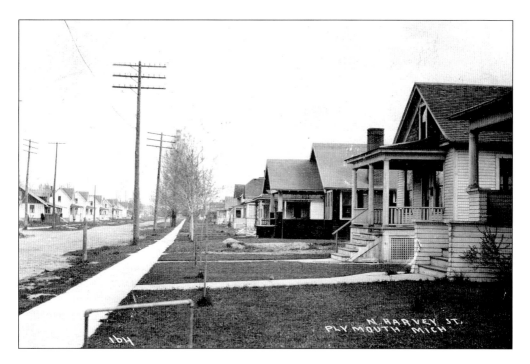

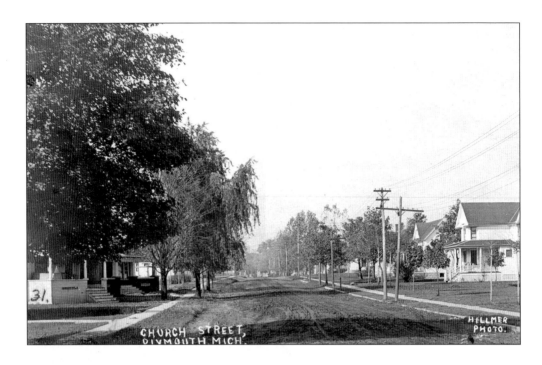

(Above) CHURCH STREET, WHICH DEAD-ENDS AT PENNIMAN AVENUE ON THE WEST END AND SOUTH MAIN STREET ON THE EAST END. At the time of this photo, Church was straight, but in later years the road was diverted to the east near Main Street. This view is looking west toward Penniman. (Below) Houses on the west side of Oak Street (later renamed Starkweather Road).

(Right) PLYMOUTH ROAD (ALSO KNOWN AS PLYMOUTH PLANK ROAD AND MAIN STREET IN PLYMOUTH) WHERE IT CROSSES THE ROUGE RIVER AFTER LEAVING PLYMOUTH HEADING TOWARD LIVONIA. Riverside Cemetery (below) is located beyond the bridge on the right on Plymouth Road. Riverside Cemetery is now the only public cemetery in the Plymouth area. In the nineteenth century, many small cemeteries were used around the township and some homesteads had burial areas. The land for Riverside was purchased by the village for cemetery purposes in 1877 from Franklin and Ellen Shattuck. The village later acquired more acreage adjoining the cemetery.

PLYMOUTH ROAD, PLYMOUTH MICH.

HILLMER PHOTO

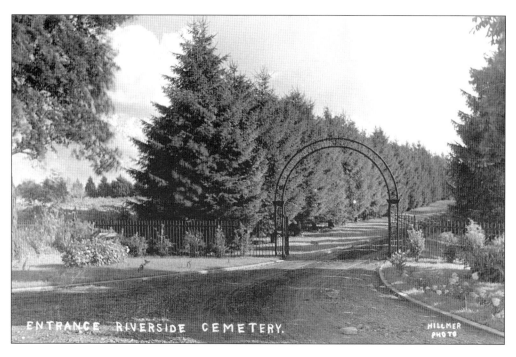

ENTRANCE RIVERSIDE CEMETERY.

HILLMER PHOTO

LOVERS' LANE. That was the local term for this footpath running along Mill Street. After Henry Ford set up his Village Industries plants in the 1920s, this path was used regularly between the Phoenix Mill Plant—that employed only women—and the Wilcox Mill Plant—that employed only men.

LLOYD L. LEWIS' HARDWOOD LUMBER PLANT, LOCATED BETWEEN THE RAILROAD TRACKS AND MILL STREET BEGINNING IN ABOUT 1891. The plant and yard covered more than four acres. Lewis was a sawyer and dealer in hardwood lumber, but also ran a flour mill and a sawmill with the capacity of 10,000 feet of lumber per day. He also ran a threshing outfit propelled by a 15-horsepower Buffalo Pitts traction engine.

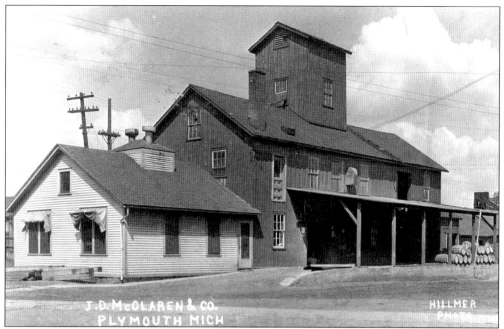

J.D. McLaren & Company. It was first a grain elevator company and later a coal and lumber business located on Main Street just north of the railroad tracks. McLaren purchased a string of grain elevators from L. C. Hough in 1901. The company closed in 1975 after the death of John J. McLaren, J. D.'s son, who took over the business in 1915 when his father died.

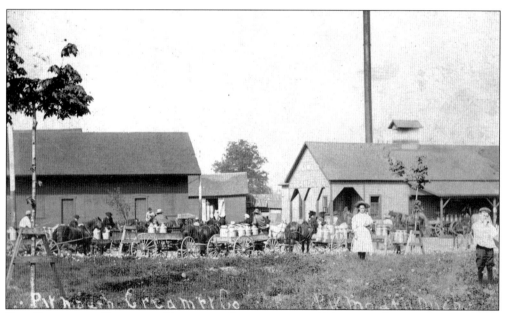

The Plymouth Creamery Company, Organized in 1901 by a Local Cooperative Group. It was off North Main Street, east of the railroad tracks and near McLaren Lumber Company. Farmers came from miles around to empty their milk cans and to exchange pleasantries with creamery superintendent Mathew Powell. About 1912, the plant became a receiving station for the Detroit Creamery Company, makers of "Velvet" ice cream.

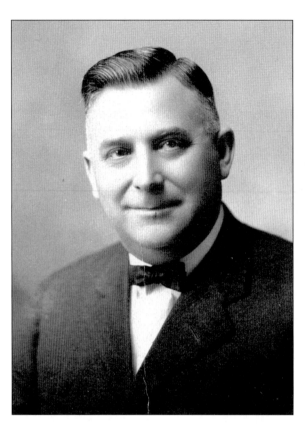

FRED D. SCHRADER (1875–1945).
He and his brother Nelson opened the Schrader Funeral Home in 1904 as an adjunct to their furniture business on Sutton Street (later Penniman Avenue). Prior to the opening of the funeral home, it had been customary for funerals to be conducted from residences. Nelson Schrader moved to Northville in 1908 and opened a branch of the funeral home there. In 1917, Fred Schrader purchased the home of his brother-in-law, Dr. Albert E. Patterson, at 280 S. Main Street and moved the mortuary end of the business there, where it remains today. (Below) Schrader's first horse-drawn hearse.

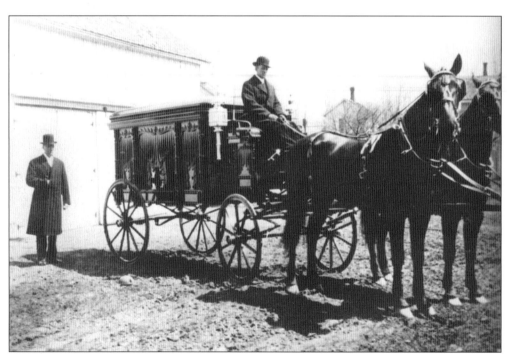

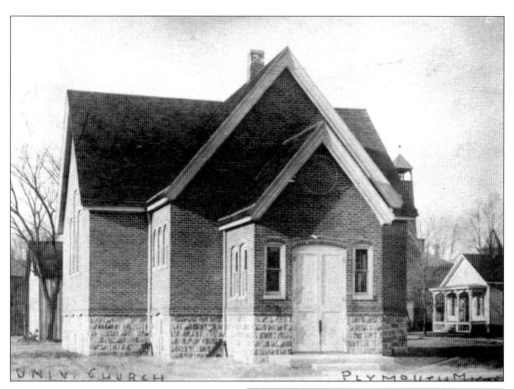

(Above) **THE UNIVERSALIST CHURCH, BUILT IN 1900 ON THE CORNER OF UNION AND DODGE STREETS.** The building was abandoned and in about 1920 the growing Catholic congregation of Our Lady of Good Counsel purchased it. The Catholics met here until it was destroyed by fire on December 23, 1932. The congregation later built a new church on the corner of Penniman Avenue and Arthur Street next to E. J. Penniman's house.

(Right) **THE CHRISTIAN SCIENCE CHURCH ON THE CORNER OF MAIN AND DODGE STREETS, DEDICATED IN 1903.** In the 1960s, the church property was sold to the City of Plymouth for its new City Hall, built adjacent to the older hall. The Christian Science congregation built a new facility on Ann Arbor Trail.

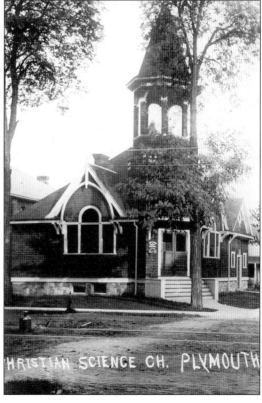

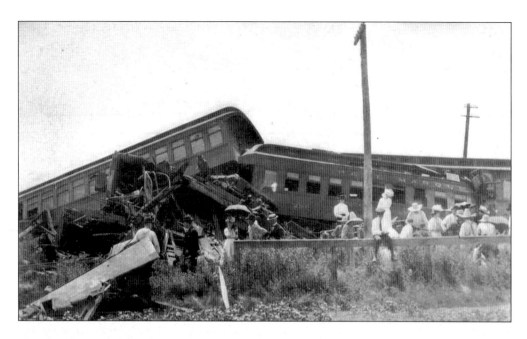

JULY 20, 1907, AN EASTBOUND PERE MARQUETTE TRAIN, FILLED WITH PASSENGERS FROM
IONIA, MICHIGAN, HURTLED AROUND A SHARP, STEEPLY EMBANKED, CURVE FOUR MILES
WEST OF PLYMOUTH. At the same time, a six-car freight train, heading west, entered the cut
on the same track. They met head on, with the result being 33 dead and 100 injured. Many
Plymouth residents headed out to Salem Township to witness the catastrophe. (Below) In
1908, a caboose from a Pere Marquette train jumped the tracks and did considerable damage to
Dan Smith's Coffee House and Hotel.

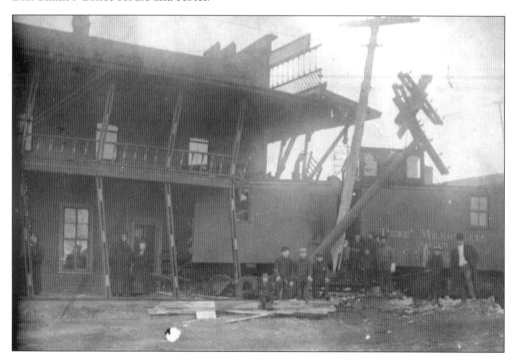

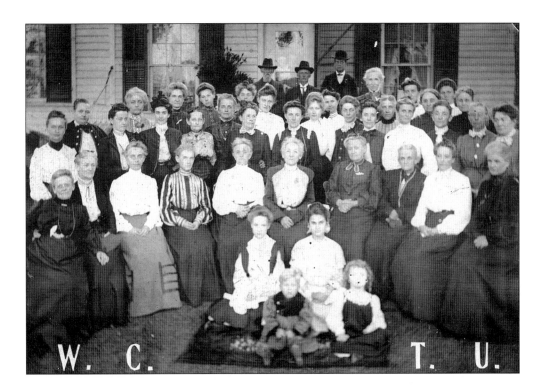

W. C. — T. U.

THE PLYMOUTH BRANCH OF THE WOMEN'S CHRISTIAN TEMPERANCE UNION. The group formed in 1877, but was most active just prior to Prohibition. Plymouth had three taverns as early as 1838. The above photo was taken in 1904. In 1908, Carry Nation, the well-known temperance agitator, gave three lectures on the evils of drink in the Baptist Church on N. Mill Street. At age 61 she was still an imposing figure at almost six feet tall, weighing 175 pounds. Her trademark and favorite weapon was a hatchet (below—from the Plymouth Museum's collection). She wielded it vigorously in many a saloon throughout the country. Mrs. Nation declared that saloon property "has no rights that anybody is bound to respect." Saloons across the country returned the compliment by placing signs in their windows reading, "All nations welcome except Carry."

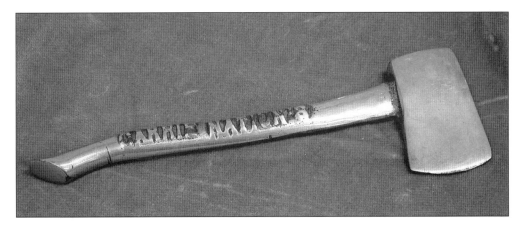

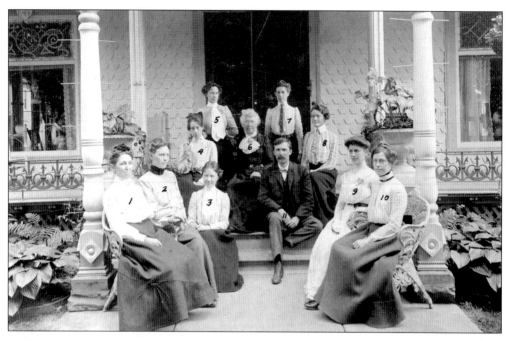

(Above) THE SUPERINTENDENT AND TEACHING STAFF OF PLYMOUTH SCHOOLS, SEATED IN FRONT OF THE TAFFT HOME, CURRENT SITE OF THE DUNNING-HOUGH LIBRARY, IN ABOUT 1903. Pictured are 1–Delia Entrican, 2–Blanche Starkweather Tighe, 3–Elizabeth Kittridge, 4–Florence Wetmore, 5–Rose Hawthorne, 6–Anna Smith, 7–Bessie Tafft Wilcox, 8–Laura Ruppert, 9–Theo. McDonald, 10–Camilla Tafft Butterfield, and 11–John E. Mealey. (Below) The Plymouth Band posing in the Penniman-Allen Park in 1909. From left to right are, front row; John Williams and Harry Robinson; middle row, Henry Sage, Floyd Sherman, Charles Halloway, Isaac Crocker, Jack Remer, Charles Lundy, Henry Tanger, William Waterman, Albert Gates, and Joseph Tessman; and back row, George Quackenbush, Lewis Cable, and Ed Quackenbush.

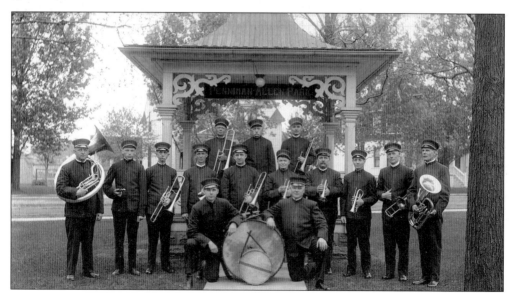

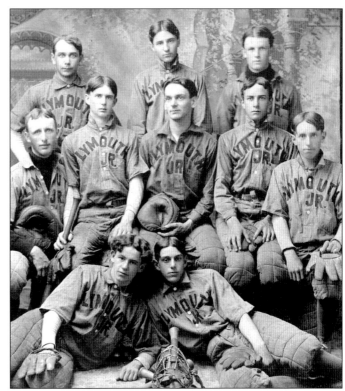

THE PLYMOUTH JUNIOR BASEBALL CLUB IN 1904. On floor from left to right are Edgar Jolliffe and John McLaren. Seated from left to right are Frank Anderson, Frank Toncray, Ernest Gentz, Roy Armstrong, and Claude Henderson. Standing from left to right are Charlie Riggs, Ray Smith, and pitcher Monte Wood.

THE PLYMOUTH HIGH SCHOOL FOOTBALL TEAM OF 1902. On floor from left to right are Perry Shaw and Edgar Jolliffe. Kneeling from left to right are Monte Wood, C. Hubbard, Ernest Gentz, F. Spicer, and Evered Joliffe. Standing from left to right are Aruna Cady, A. Chilson, Ray Smith, Roy Lang, and unidentified.

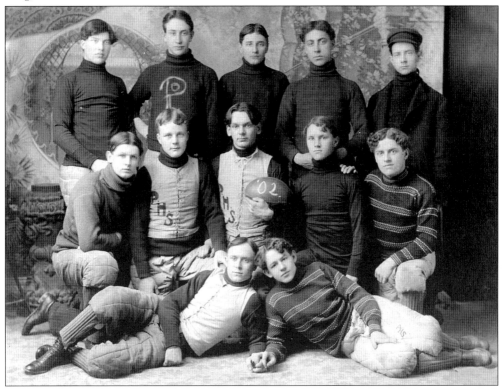

A SEWING CIRCLE MEETING IN FRONT OF THE FRALICK FARMHOUSE ON THE CORNER OF FRALICK AND MAIN STREETS IN 1904. On the porch from left to right are Ella Fralick Safford, Phila Safford Harrison and son Kenneth, Maude Pettingale, and Miss Buell. On the lawn from left to right are Jean Brisbon, Nettie Dibble, Ella Chaffee, Delia Entrican, Maggie Joy Dickerson, Mrs. Karl Hillmer, Zaida Burrows, Harriet Wilcox, Mrs. Alfred Chaffee, Maude Cooper, Alice Safford, Ann Baker, and the dog is Max.

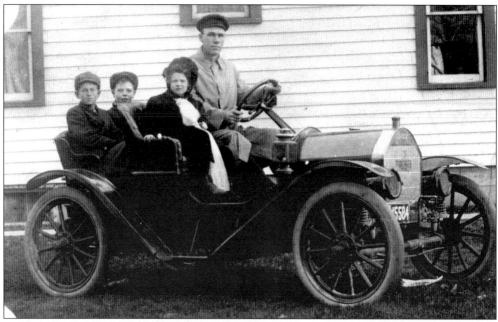

FRANK HAMILL IS AT THE WHEEL OF HIS BRUSH RUNABOUT—A 6-CYLINDER, CHAIN-DRIVEN AUTO AND EQUIPPED WITH CARBIDE LIGHTS AND SPONGE RUBBER TIRES. In the front seat with Frank is Alta Hammill, and in the back seat are Harry Sales and Herald Hamill. Frank Hamill was the railroad station agent in Plymouth.

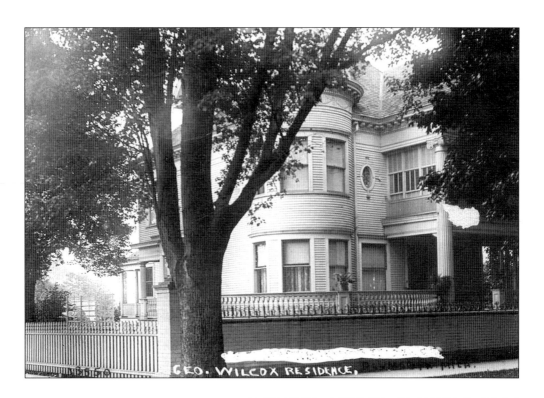

GEO. WILCOX RESIDENCE,

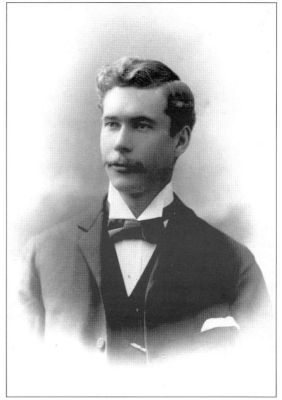

WILLIAM F. "PHILIP" MARKHAM BUILT THE HOME ABOVE IN 1901 TO LIVE IN WITH HIS MISTRESS AND SECRETARY, BLANCHE SHORTMAN. Markham's wife Carrie would not agree to a divorce, but upon her death in 1910, Markham married Shortman. Tired of the way the Markhams were treated by Plymouth society, Philip sold Markham Air Rifle Company and the air rifle patents to Daisy and moved to Hollywood, California. Daisy renamed the company King Manufacturing Company and continued to sell the air rifles under that name. (Right) George Henry Wilcox (February 4, 1873–June 10, 1935) bought Markham's home in 1911 and lived there with his wife Harriet. Their son, Jack, lived in the house for 83 years until his death in 2000. The house is in the process of being renovated and the surrounding land is being developed into condominiums.

111

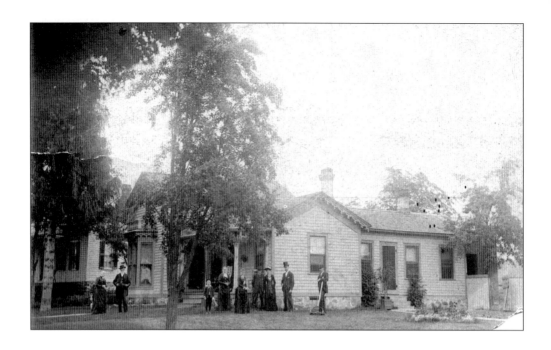

(Above) **THE WILLIAM BASSETT HOME AT 908 PENNIMAN AVENUE.** From left to right are Mrs. William Bassett, William Bassett, Frank J. Burrows, Mrs. Mary Park, Mrs. William J. Burrows, James Park, Mrs. May Bassett, Albert Bassett and William Bassett Jr. (Below) The Frank J. Burrows home at 870 Penniman Avenue in 1903. The home was next to the post office built in the 1930s; the house burned down in 1996 and the lot is now vacant. The people in the photo are unidentified. (Photos courtesy of Garry Packard.)

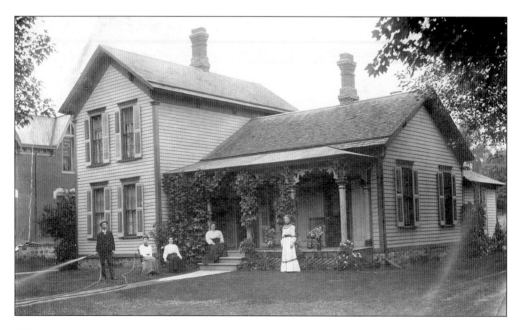

Seven
1911–1920

**MRS. PHOEBE PATTERSON
(1857–1931).** She was elected in 1919
as the first female Justice of the Peace
of the state of Michigan—and she had
to fight a court battle herself to keep
her position. After her election, her
position was challenged by a lawyer,
James Pound, who felt that even
though women could vote, they had no
right to hold office. Her position was
upheld and her case became a
significant cause throughout the state
for women. By 1927, there were six
other female justices in the state.

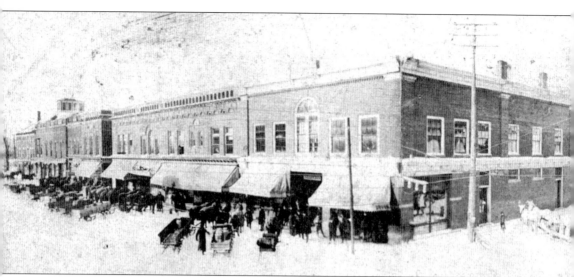

SOUTH MAIN STREET AND PENNIMAN AVENUE (LOOKING WEST) IN WINTER, BETWEEN 1915 AND 1920. The Conner Building on the northwest corner of Main and Penniman was built in 1898 and is still standing. The structures to the north of the Conner Building were replaced in

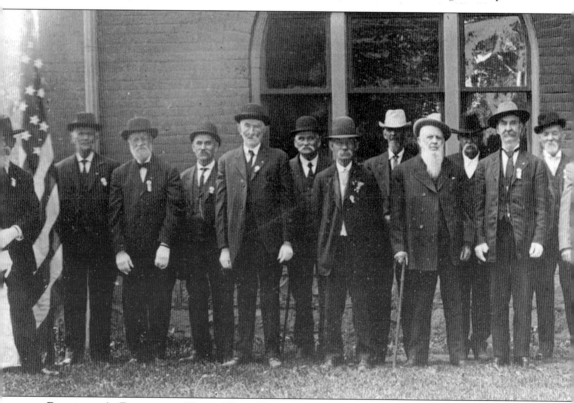

PLYMOUTH'S REMAINING CIVIL WAR VETERANS POSED TOGETHER IN FRONT OF VILLAGE HALL IN ABOUT 1915. From left to right are Asa Joy, Ephraim Partridge, T. V. Quackenbush, William Smitherman, Chris Peterhans, James Manzer, Oliver Showers, Pizarro Perkins, Dr. Abram Pelham, Orson Westfall, Mr. Peterquin, Willard Roe, John Stewart, Chauncey Bunyea,

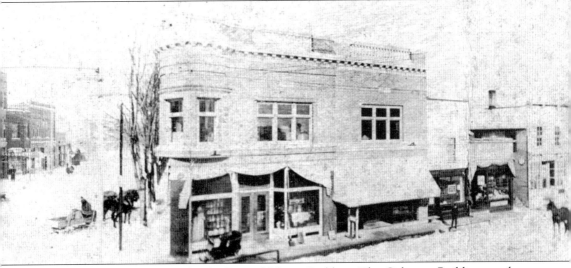

the 1930s with the current Schrader Funeral Home Building. The Coleman Building on the southwest corner of Main and Penniman was replaced in the early 1920s with a bank building that stands vacant today.

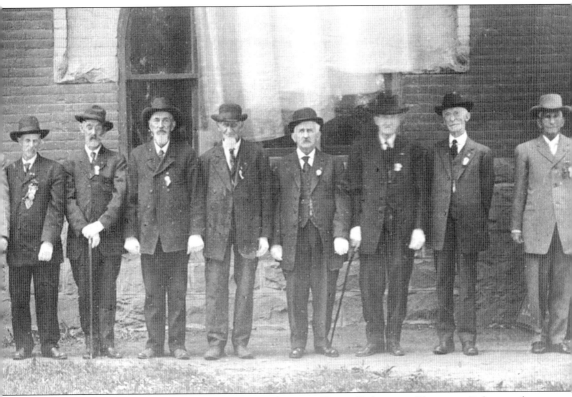

Mr. Maynard, James B. Purdy, John Burden, unknown, Henry Robinson, Chauncey Baker, and A. N. Brown. One other Civil War veteran, Arthur Stevens, was late for the photo and does not appear.

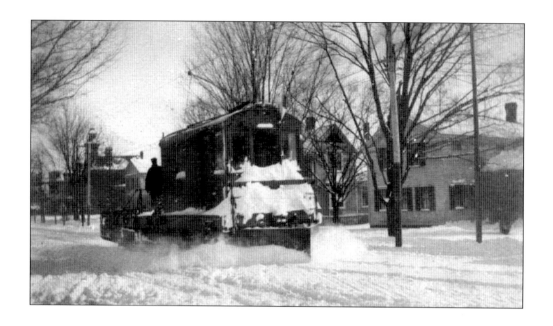

THE INTERURBAN, IN SERVICE REGARDLESS OF THE WEATHER. (Above) With a plow on the front, the Interurban cars could easily make their way along the tracks. (Below) The Phoenix and Interurban bridges shortly before the Phoenix dam collapsed and the bridges caught fire.

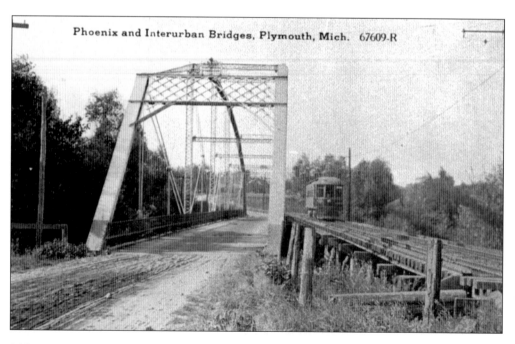

Phoenix and Interurban Bridges, Plymouth, Mich. 67609-R

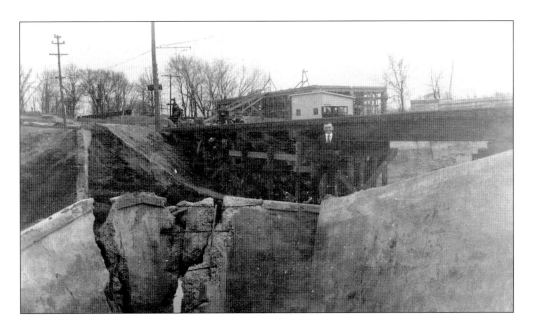

(Above) **THE PHOENIX DAM ON THE ROUGE RIVER.** It collapsed on April 18, 1920, taking the Interurban Bridge with it in a ball of fire. The man in the center of the photo is unidentified.

(Below) **INTERURBAN BRIDGE.** Work began immediately to rebuild the Interurban bridge as it was what connected Plymouth and Northville by rail, until the Interurban stopped running in 1924.

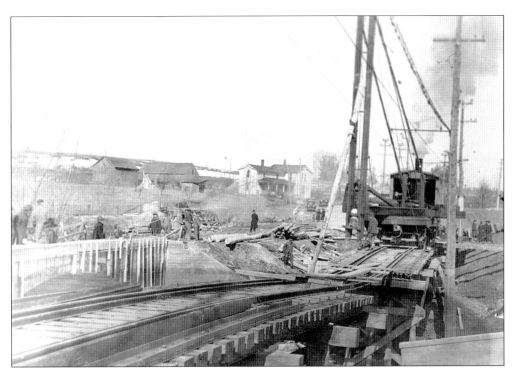

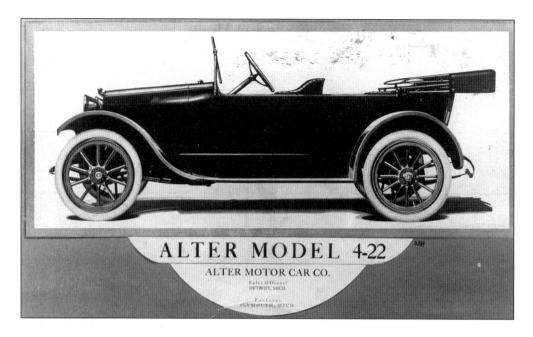

ALTER MODEL 4-22

ALTER MOTOR CAR CO.

Sales Officer
DETROIT, MICH.

Factory:
PLYMOUTH, MICH.

ALTER MODEL 4-22. On January 26, 1914, Detroit businessmen interested in opening an automobile plant held a meeting in Plymouth. The proximity of two major rail lines made Plymouth an ideal location. The founding businessmen decided to sell stock to local people. Many bought the stock, and work began on factory construction in the spring of 1914 while a committee looked at prototypes of automobiles. Soon the Alter Motor Car Company went into business producing a car designed by Clarence Alter of Manitowoc, Wisconsin. The car was made of component parts shipped here by rail and then assembled at the factory. The car sold for $685 and had a 27 horsepower motor, 12-gallon fuel tank under the cowl, and a wheel base of 108 inches. By late 1916, the company found the factory was too small to keep up with the backlog of orders but was unable to acquire additional funding for expansion and went into receivership. The original buildings belonging to the Alter Motor Car Company still stand on Farmer Street adjacent to the railroad tracks. The only known Alter Car still existing is on permanent display at the Plymouth Historical Museum.

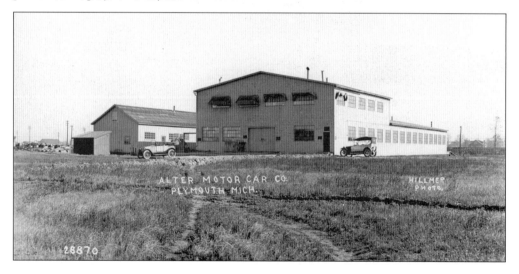

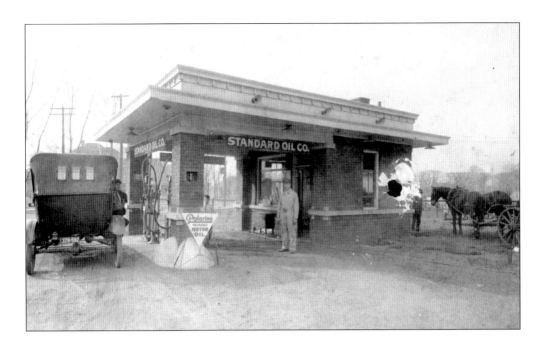

MILLER GAS AND THE BONAFIDE GARAGE. Along with the automobiles came the gas stations and dealerships. (Above) Miller Gas Station was at the corner of Wing and Main Streets. This photo dates to between 1918 and 1920—note the horse and buggy on the right of the station. (Below) William J. Beyer bought the Ford dealership from John J. McLaren in about 1915 and renamed it the Bonafide Garage. The name came from the Bonafide Manufacturing Company that McLaren had been running from the second floor of the building, which manufactured fish lures and frog spears. In 1919, Beyer sold Ford Touring Cars for $525.

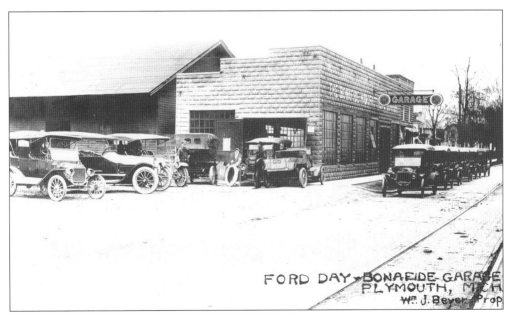

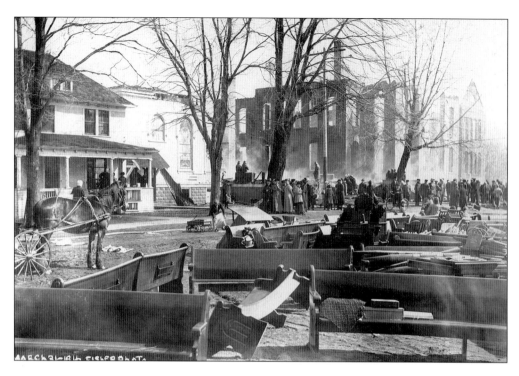

PLYMOUTH HIGH SCHOOL FIRE. (Above) The Plymouth High School Fire of March 31, 1916 is believed to have started in the furnace room. The Methodist Episcopal Church adjacent to the high school also burned in the fire. (Below) Both the high school and the church were replaced on the same locations. The building pictured is the new Plymouth High School. The building received later additions and is used today as Central Middle School.

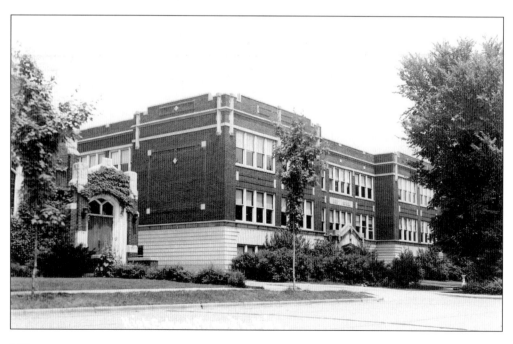

PLYMOUTH HIGH SCHOOL FIRE. The fire of the High School displaced students in all grades that were attending school in that building. Until the new school was built, students pursued their studies in various buildings in the village. One of the buildings temporarily used for classes was Kate Penniman Allen's carriage house (above) on Penniman Avenue. The Knights of Pythias Hall, John Gale's Store, and the Christian Science Church were also used.

HELEN FARRAND. Helen Farrand (1892–1977) was the daughter of Plymouth resident William Farrand. She took a six-week teaching course at Ypsilanti Normal School (now Eastern Michigan University) and began teaching in Dearborn Township in 1912. She taught from 1914 to 1918 at the Newburg School and went to work at the Detroit Post Office during World War I. She returned to teaching in 1923 at the Patchen School and in 1927 she came to teach in Plymouth schools. She taught at Central Grade School, Starkweather School, and Edna Allen School and retired in June 1958. In December 1958, a new elementary school was named the Helen Farrand Elementary School in her honor. The school is still in use.

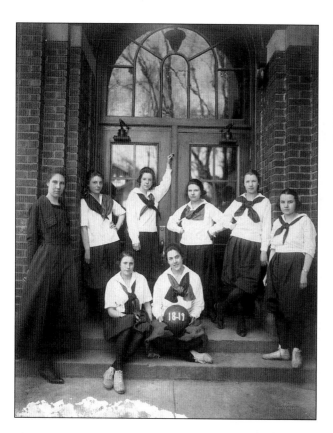

A First for Plymouth. Perhaps the first girls' basketball team fielded by Plymouth High School was during the 1918–1919 school year. The teacher is identified as Cornelia Mueller, but none of the girls are identified.

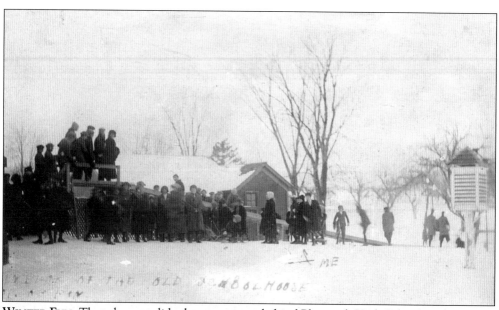

Winter Fun. The toboggan slide that was put up behind Plymouth High School in about 1915 was a very popular winter sporting attraction for Plymouth residents.

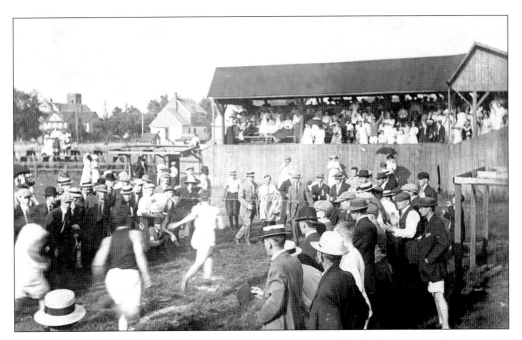

SPORT. The ball field—opened in 1905—and the land behind Plymouth High School was donated by George Starkweather. Sporting contests, such as the foot race above, were frequent occurrences in the village. (Below) Daisy Manufacturing Company entered teams into competition in both baseball and basketball as early as 1911. Only two players are identified in this photo: Claude Williams (bottom row, second from left) and William Taylor (top row on left).

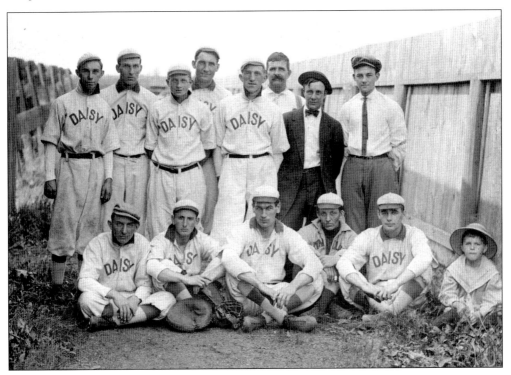

123

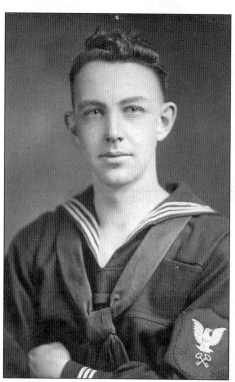

FRED HOLLAWAY. Fred Hollaway (1892–1965) served in the U.S. Navy during World War I. Before going off to war, he married Bessie Robinson on March 14, 1917.

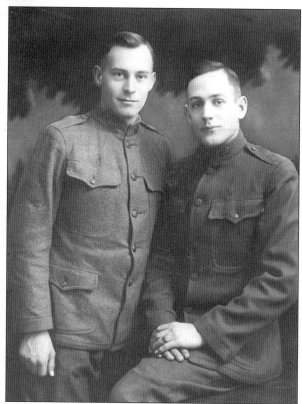

HARRY AND ORO BROWN. Brothers Harry Brown (1889–1973) and Oro Brown (b. January 21, 1891) both served in the U.S. Army during World War I.

LUSINA FULLER ROBINSON. Lusina Fuller Robinson (1864–1950), wife of Harry Robinson, served with the Red Cross during World War I. This photo is from 1918.

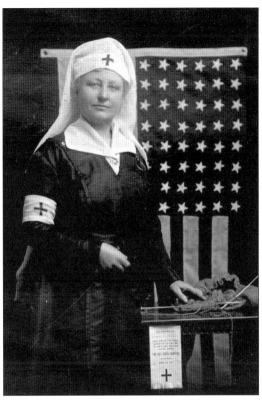

SERGEANT MYRON BEALS. Sergeant Myron Beals (1896–1918), on right, served in the U.S. Marines during World War I and was killed in action. Myron was the son of Frank W. Beals. The other Marines are not identified.

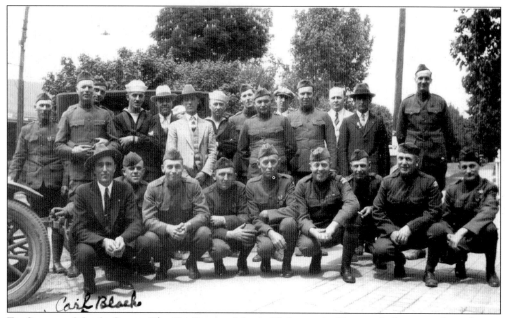

EX-SERVICE MEN'S CLUB. The Ex-Service Men's Club met in Plymouth for a number of years after World War I. The Plymouth Historical Museum has some of the organization's records. Crouching, left to right, are Lonny Brockelhurst, Harry Hunter, Howard Eckles, unknown, unknown, Harry Mumby, unknown, Lee Sackett, and unknown. Two men in the back row are identified as Carl Black (fourth from left) and Veto Simonetti (sixth from right).

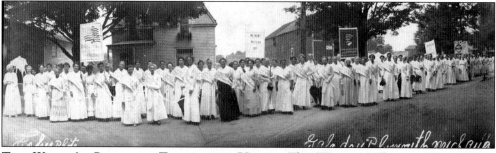

THE WOMEN'S CHRISTIAN TEMPERANCE UNION. The Women's Christian Temperance Union, Plymouth Chapter, marched in the August 1916 Plymouth Gala Day Celebration. The group not only protested the liquor laws, but it also represented women's right to vote. Czar Penney's house and livery barn are in the background on S. Main Street.

DR. LUTHER PECK. (Right) Dr. Luther Peck (1880–1963) was a colorful physician for more than half a century in Plymouth. His home and office were on the southwest corner of Ann Arbor Trail and Deer Street. Many of Plymouth's older native residents can claim that Dr. Peck brought them into the world. (Below) Dr. Peck is behind the wheel of his 1915 Ford Model T touring car with top folded back. With him in the front seat is Rose Hillmer Holstein and in the back seat are Miss O'Toole and Amelia Davis Starkweather (wife of George Starkweather and grandmother of Rose in the front seat).

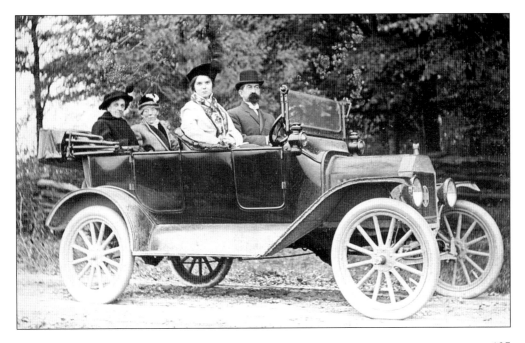

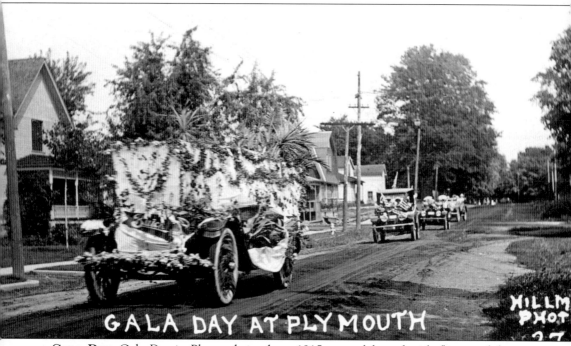

GALA DAY AT PLYMOUTH

GALA DAY. Gala Day in Plymouth in about 1915 was celebrated with floats and festivities much as celebrations are held in Plymouth today. Plymouth has long been known to be a festive place with a small-town atmosphere. Yesterday's Gala Day and Horse and Buggy Day have been replaced with the annual Fourth of July Parade at 7:30 a.m.—the earliest parade of the day in Michigan; Art in the Park in July; Fall Festival in September; Chili Cookoff in October; and the International Ice Spectacular in January. It's a "Norman Rockwell" kind of town that just keeps on thriving.